AUG 1 4

Art of India

(The Mughal Empire)

PARKSTONE®

INTERNATIONAL

Page 4:
Defying Mihrdoukht, page from a Manuscript of the *Hamzanama*, 1564-1569.
68 x 52 cm. Madame Maria Sarre-Humann
Collection, Ascona. (Switzerland)

Page 6:
Lord Pathan on horseback, armed with a spear, c. 1720.
Opaque watercolour and gold, red border with golden garland,
margin of multi-coloured leaves, probably Nepenthes,
27.3 x 19.5 cm; folio, 40.3 x 27.3 cm.
Bibliothèque nationale de France, Paris.

Author:
Vincent Arthur Smith

Layout:
Baseline Co. Ltd
61A-63A Vo Van Tan Street
4th Floor
District 3, Ho Chi Minh City
Vietnam

© 2014 Confidential Concepts, worldwide, USA
© 2014 Parkstone Press International, New York, USA
Image-Bar www.image-bar.com

ISBN: 978-1-78310-020-0

Printed in China

"O Soul, thou art at rest. Return to the Lord at peace with Him, and He at peace with you. Enter you, then, among My honoured slaves, and enter you My Paradise!"

– passage from the Qur'an inscribed at the Taj Mahal

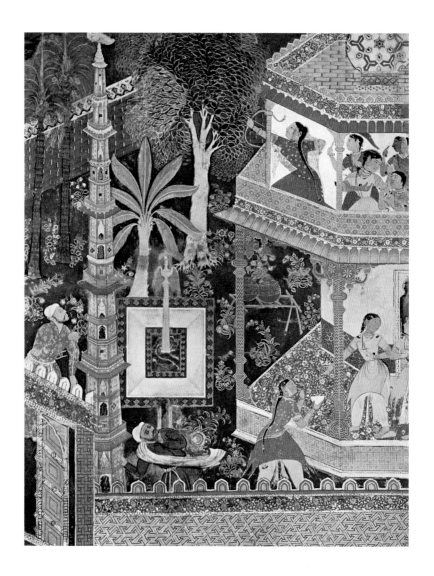

4

Chronology

1526: Zahiruddin Babur sets out upon the conquest of India. Later he becomes the first Mughal emperor. He dies in 1532.

1546: Nasiruddin Humayun, his son, is deprived of his empire by the Afghan, Sher Shah, and until his final victory in 1555 exists as a landless refugee.

1550: Two artists join Humayun's court at Kabul: Mir Sayyid Ali and Khwaja Abd as-Samad. The history of Mughal painting begins with the name of Mir Sayyid Ali, who is commissioned to supervise the illustration of *Dastan-e-Amir Hamza* (*The romance of Amir Hamzah*) in twelve volumes of a hundred folios each.

1556: Jalaluddin Akbar ascends the throne of the Mughal Empire. He accords the title of nobility to Ustad Mansur, a Mughal painter and court artist. Another artist, Govardhan, is one of the illustrators of the *Baburnama* (*Book of Babur*). Akbar dies in 1605. The painter Basawan illustrates the *Akbarnama*, Akbar's official biography, which is an innovation in Indian art.

1569: The construction of the city Fatehpur Sikri heralds a new era of Indian rule. Architects, masons, and sculptors are involved. Painters decorate the walls of the public halls and private apartments.

1570: Completion of Humayun's mausoleum in Delhi.

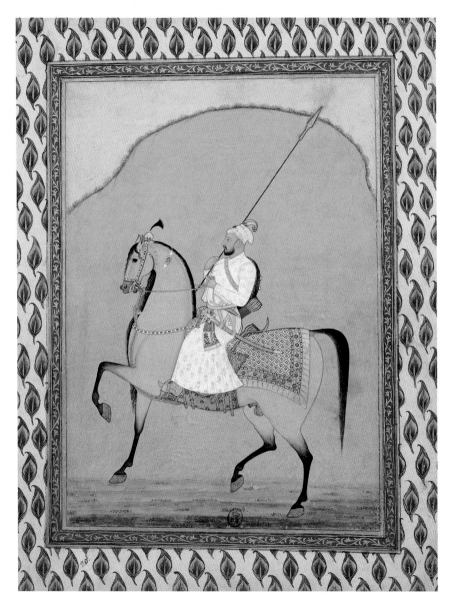

6

1570: Begin of the Indo-Persian or Mughal School of drawing and painting.

1573: Illustration of a manuscript of *Hamzanama*, originally consisting of 1400 miniatures.

1590: A hundred artists are reckoned to be masters of their craft.

1605: Nuruddin Jahangir, Akbar's son, becomes the new Mughal Emperor. He reigns until 1627. During his reign Ustad Mansur creates a series of eight exquisite little miniatures for the *Waqiat-i-Baburi*.

1628: Coronation of Shah Jahan, the third son of Jahangir. He dies in 1657.

1628: Completion of the I'timad-ud-Daulah Mausoleum.

1648: Completion of the main mausoleum of the Taj Mahal in Agra.

1648: Completion of the Red Fort in Delhi for Shah Jahan.

1659: Coronation of Aurangzeb Alamgir, he dies in 1707.

1674: Completion of the Badshahi Mosk.

1820-1830: End of the Mughal School.

1857-1858: End of the Mughal Empire in consequence of the foundation of the colony British-India.

India and Its Art

In discussing Indian studies I am forced to acknowledge considerable diffidence arising from a survey of the huge bulk of material to be dealt with. In the face of this complexity I find myself inclined to rely on evidence that is subjective and therefore more or less unscientific, in which personal experience and interpretation is increasingly stressed. In speaking of India, a country that in its wide extent offers more beauty to the eyes than many others in the world,

Humayun Mausoleum

Red sandstone, 1570
Delhi

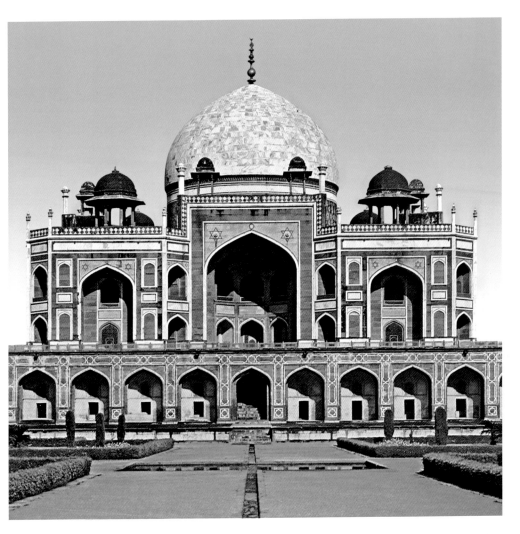

a descriptive vein may well be excused. India is multiple; neither geographically, ethnologically, nor culturally can it be considered a unity. This being so, I am led to suspect that the India of many writers is more imagination than fact, existing rather in pictorial expression than in reality.

The appeal of the pictorial, rising from a craving for colour and movement, is general among the generations of the present, continually chaffing against narrowed horizons and an experience bounded by economical necessity.

Diwan-i-Khas (Hall of Private Audience)

c. 1571, Akbar period
Red sandstone
Fatehpur Sikri, Uttar Pradesh

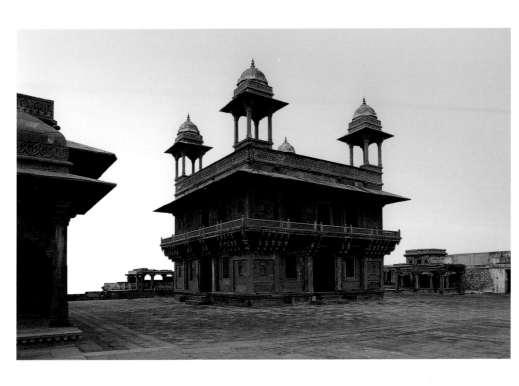

There is magic to be found anywhere between Cancer and Capricorn. There the demands of necessity would seem to be more easily fulfilled and life to run more rhythmically, in the train of the tropic alternation of the seasons. There, bread is to be gathered direct from the rich lap of the earth. There, colour fills the day with its wealth, leaping to the eye, like the sudden glow of fruit and flower caught by the sunlight, or of kaleidoscopic crowds in narrow streets. To enter a tropic town is to enter, as in a dream, the life of a dead century.

Arches in the Great Mosque Jama Masjid

1571, Akbar period
Red sandstone with white marble
and green and blue enamel inlay
Fatehpur Sikri, Agra, Uttar Pradesh

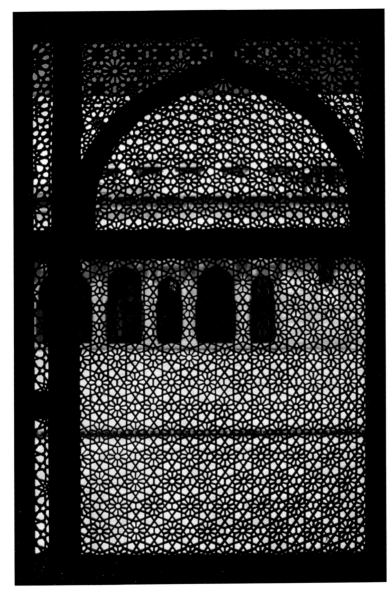

13

The movement is not without parallels, and the pictorial and interpretational play a great part in its exposition; there is, indeed, something of the Pre-Raphaelite about it. The materialism of today is to be checked by Indian spirituality. Arts and crafts are to flourish everywhere, centred upon the social organization of the village. India is to arise from the ashes of India. It might be claimed, therefore, that there could be no better time than the present for the publication of a survey of Indian Fine Arts,

Young girl with parrot

Page from a Manuscript of the *Tutinama* (*Tales of a Parrot*), 1580-1585
17 x 13 cm
Chester Beatty Library, Dublin

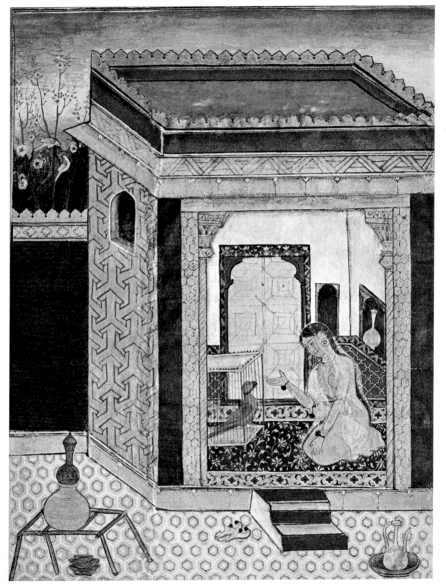

15

that the credit and loss of the exchange between the occidental and the oriental may be appraised. Indeed this nationalization of the subject has been set forth at length by certain authors. It is, however, in contradistinction to the spirit of true criticism and full appreciation. The opposition of Eastern spirituality to Western materialism is a generalization without support, while the postulation of a metaphysical basis for any art is equally as sterile, and in fact as inconsequential,

Episode from the tale of *The Lynx and the Lion*

Niccolò Manucci, page from a Manuscript of the *Tutinama* (*Tales of a Parrot*), 1580, Akbar period, Patan, Gujarat Opaque watercolour and ink, 31.9 x 22.9 cm Virginia Museum of Fine Arts, Richmond

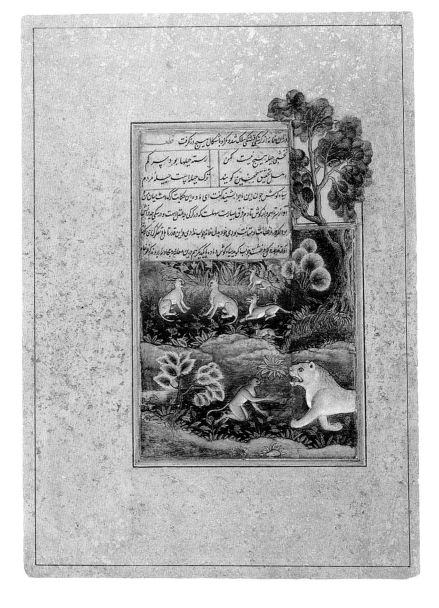

as the postulation of the existence of eternal, immutable classical standards. Art cannot be localised, at least if the humanities upon which our culture is based have any meaning, and geographical differences should be no bar to appreciation, but rather an added attraction in these days, when for most of us our voyages of discovery do not exceed the bounds of the local time-table. It is, however, unfortunate that in the minds of many people the East has a certain

Murder in a landscape

c. 1580
Opaque watercolour and gold
orange border with gold-plated garland
margin adorned with polychrome flowers and gold
13.6 x 14.7 cm; folio, 32.5 x 29 cm
Bibliothèque nationale de France, Paris

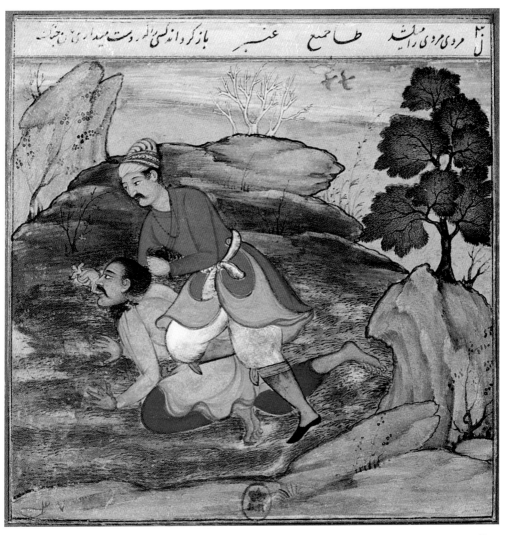

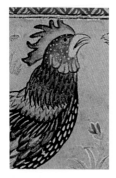

romantic but quite indefinite lure about it, which accentuates the unusual and leads to the substitution of curiosity for appreciation. Modern painting and sculpture provide a definite line of advance and logical precepts to an extent that almost makes academicians of many of the younger school. This process is directly comparable to that of the modern scientific method; modern art is indeed the result of methodical, aesthetic research. From the painting of Manet to that of Cezanne and the men of today,

Cockfight

Illustration from *'Aja 'ib al-makhlukat* (*Wonders of the creation*) of Qazvinic, c. 1585 Opaque watercolour, red border with gold chevrons margin with blue flowers, 10.4 x 20.1 cm Bibliothèque nationale de France, Paris

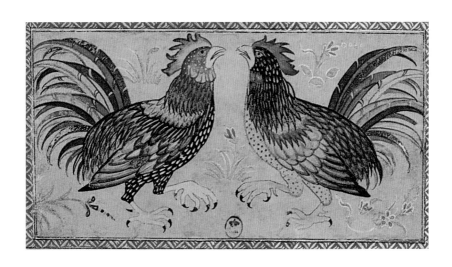

the story can only be told in terms of intellectual adventure and aesthetic discovery. The effect of the personal vision of the creators of modern art has been a widening of the circle of aesthetic interest and a revaluation of things unknown or unconsidered: Chinese painting and sculpture, Gothic sculpture, archaic Greek sculpture, African sculpture, the harmony of fine carpets, the virility of primitive design, and not least among these, Indian Art in all its branches.

Davalpa mounted on a man

Illustration from *'Aja 'ib al-makhlukat*
(*Wonders of the creation*) of Qazvinic, c. 1585
Opaque watercolour and gold, border on blue paper
margin with bouquets of colorful flowers, 20.6 x 11.6 cm
Bibliothèque nationale de France, Paris

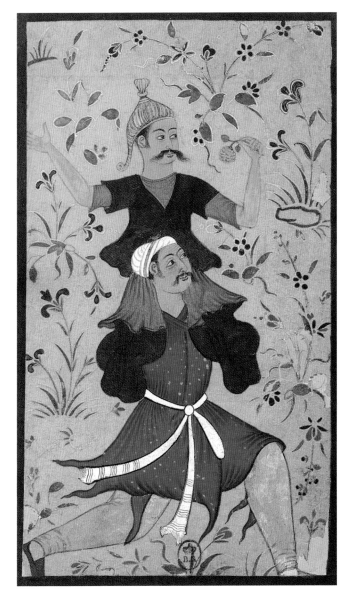

23

In the face of these riches, once despised and rejected, the dogmas of the past generations with all their complacency, intolerance, and ignorance seem wilful in their restriction and impoverishment of life. So vital and so well founded is this movement that I would choose, as the theme of a review of Indian Art, aesthetic discovery rather than archaeological discovery, and for support I would rely upon the word of living artists whose creative vision and

Episode from the tale of *The False Ascetic*

Page from a Manuscript of
the *Kathasaritsagara*, c. 1585-1590
Opaque watercolour and ink, 16.4 x 13.5 cm
Virginia Museum of Fine Arts, Richmond

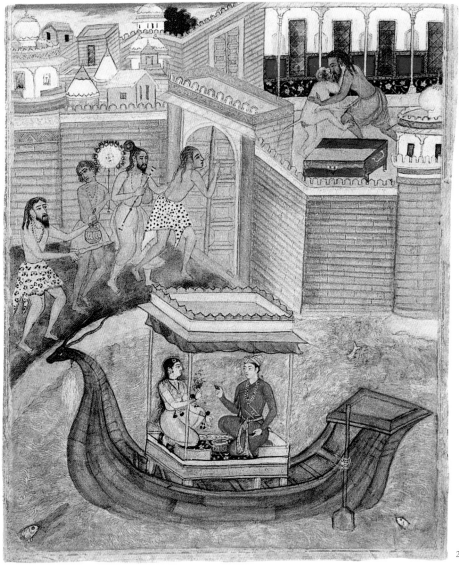

25

fellow appreciation provides the basis of a criticism of greater precision than archaeological logic or the ulterior ends and confused categories of evidence of those who would carry the discussion beyond the proper field of art. I cannot believe it is necessary or even desirable to prelude the vision of a work of art with many words. Nor can I accept as sound criticism a discourse which shifts the foundations of a true understanding of art from the visual into the literary or historical or metaphysical.

The arrival of Nanda and his family in Vrindavan

Page from a Manuscript of the *Harivamsha*
1586-1590
Akbar period, Patan, Gujarat
Opaque watercolour and ink, 40.8 x 30 cm
Virginia Museum of Fine Arts, Richmond

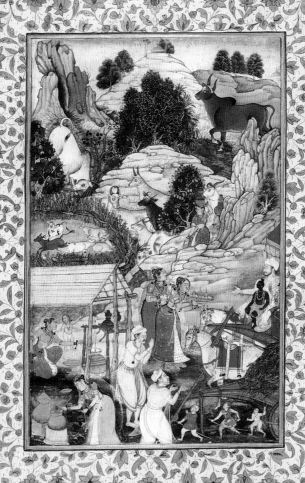

27

I can but deplore the twisting awry of aesthetic criticism and appreciation to local and temporary ends, whatever the circumstances.

On 28 February 1910, the following declaration appeared in *The Times* above the signatures of thirteen distinguished artists and critics:

We, the undersigned artists, critics, and students of art... find in the best art of India a lofty and adequate expression of the religious emotion of the people and of their deepest thoughts on the subject of the divine. We recognize in the Buddha type of

Portrait of Kishn Das Tunwar

Kanha, page from the *Salim Album*
1590, Akbar period, Patan, Gujarat
Opaque watercolour and ink, 23.8 x 15.1 cm
Virginia Museum of Fine Arts, Richmond

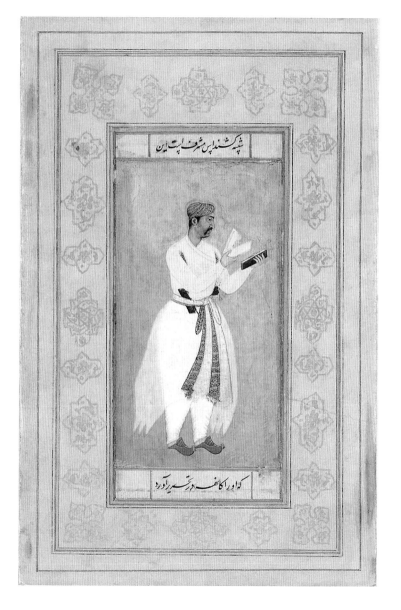

sacred figure one of the great artistic inspirations of the world. We hold that the existence of a distinct, a potent, and a living tradition of art is a possession of priceless value to the Indian people, and one which they, and all who admire and respect their achievements in this field, ought to guard with the utmost reverence and love. While opposed to the mechanical stereotyping of particular traditional forms, we consider that it is only in organic development from the national art of the past that the path of true progress is to be found.

Interior of the Sheesh Mahal (Hall of Mirrors)

1592, Akbar period
Minute mirror work inlaid in the ceiling
of the Winter Palace of Amer Fort, Amer

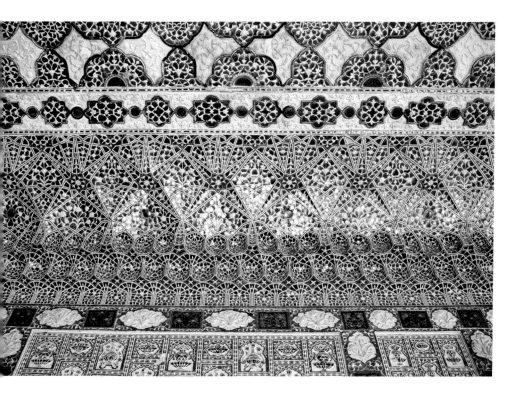

Confident that we here speak for a very large body of qualified European opinion, we wish to assure our brother craftsmen and students in India that the school of national art in that country, which is still showing its vitality and its capacity for the interpretation of Indian life and thought, will never fail to command our admiration and sympathy so long as it remains true to itself. We trust that, while not disdaining to accept whatever can be wholesomely assimilated from foreign sources,

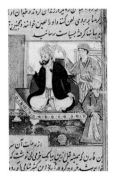

Events during the Reign of the Abbasid Caliph al Mutasim

Page from a Manuscript of the *Traikh-i-Alfi*
1593-1594, Akbar period
Opaque watercolour and ink, 41.1 x 25.4 cm
Virginia Museum of Fine Arts, Richmond

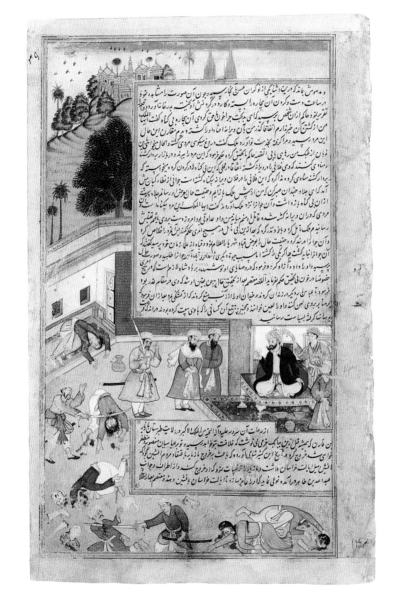

it will jealously preserve the individual character which is an outgrowth of the history and physical conditions of the country, as well as of those ancient and profound religious conceptions which are the glory of India and of all the Eastern world.

This declaration was directly caused by a paper read before the Royal Society of Arts by Sir George Birdwood, the chronicler of Indian industrial arts. As a matter of fact, all that was then said had already appeared in print thirty years before,

Hulagu Khan destroys the Fort at Alamut

Basawan (illustrator) and Nand Gwaliori (colourist)
Page from a Manuscript of the *Chinghiznama*
1596, Akbar period
Opaque watercolour and ink, 38.4 x 24.9 cm
Virginia Museum of Fine Arts, Richmond

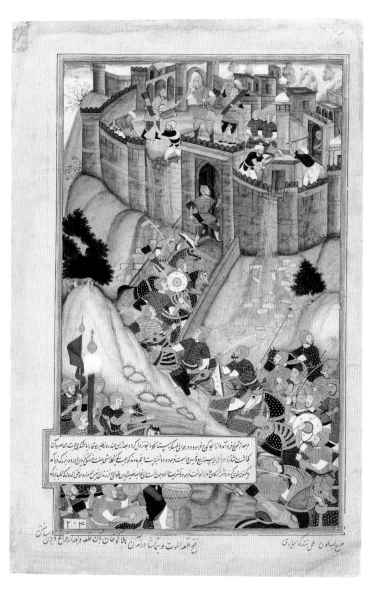

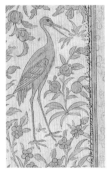

but the moment was not then ripe for the acceptance of the challenge. Birdwood can in no way be accused of lack of sympathy with Indian life or Indian things. A stylistic analysis of the crafts of modern India is illuminating with regard to one's attitude to the country itself, for one is forced to acknowledge the predominance of the Islamic and especially of the Persian culture of the Mughal court. Except in their everyday household form, pottery and metalwork are purely Islamic.

Muzaffar Khan quells a revolt at Hajipur

Page from a Manuscript of the *Akbarnama*
1596-1597, Akbar period
Opaque watercolour and ink, 12.7 x 19 cm
Virginia Museum of Fine Arts, Richmond

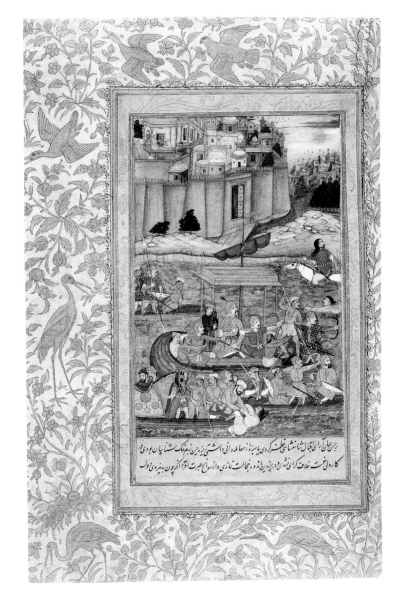

بزرگ خان آمد که ناگاه اقبال باشاهی بنظر کردی باسید ازمعامله دانی داشتی بزرگ نزد فرنگ مشایبان بوده من
کار واین نسبت خلاف گرای نشین درپیین نذود بمخالفت نامدی وازسلاح عبرت آقا آنک جوان پیروی مول

Textiles, especially prints and brocades, are very largely Persian in design, although the Indian strength of imagination and purity of colour are evident. Certain forms of textiles are, however, purely Indian, the darn-stitch Phulkaris of the northwest and certain tied-and-dyed and warp-dyed forms. Only in jewellery has the Indian tradition been wholly preserved, in the beadwork of the villages as well as in the enamels of Jaipur. Birdwood's love of all this delicate and colourful craftsmanship, and of the complex,

Visit of a Sufi to a school

1595-1600, Akbar period
Opaque watercolour, 33.3 x 21.7 cm
Virginia Museum of Fine Arts, Richmond

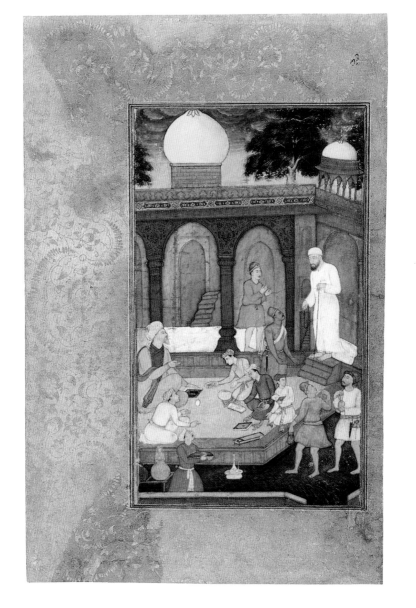

39

changeful life of which it is a part, is expressed in many passages from his pen of very great beauty. The arts of Ancient and Medieval India were outside his field, and his criticism of them is not deeply considered and purely personal.

The popularization of Indian art has been mainly the work of Dr Ananda Coomaraswamy and E. B. Havell. To a certain extent their methods of exposition agree, the vein being interpretational, with a stressing of the literary.

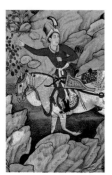

Zaal pleads with the Simurgh to save his son Rustam

Miskin (attributed to), Illustration of the *Shahnameh* (*Book of Kings*) by the Persian poet Firdousi c. 1595-1605, Jahangir period Gouache and gold, 27 x 18 cm; folio, 40.3 x 27.3 cm Bibliothèque nationale de France, Paris

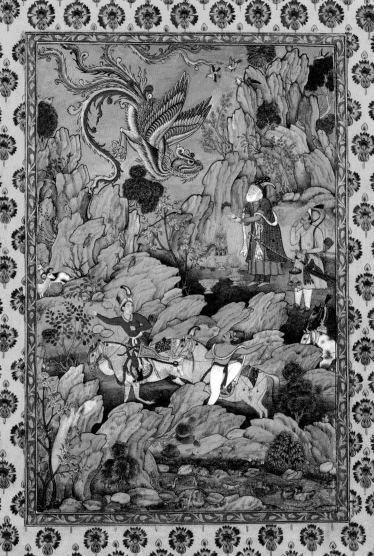

41

For Dr Coomaraswamy, "all that India can offer to the world proceeds from her philosophy", a state of "mental concentration" (yoga) on the part of the artist and the enactment of a certain amount of ritual being postulated as the source of the "spirituality" of Indian art. The weakness of this attitude lies in its interweaving of distinct lines of criticism, form being dressed out in the purely literary with the consequent confusion of aesthetic appreciation with religious and

Emperor Humayun

17th century
Opaque watercolour and gold, gilded edges and red wash,
margin of sandblasted gold, 20.5 x 12 cm; folio, 45 x 32 cm
Bibliothèque nationale de France, Paris

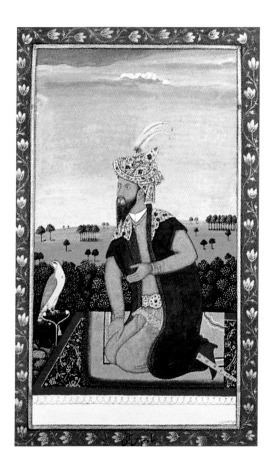

other impulses. It is also historically ill-founded, for the sentiment and philosophy out of which the web is spun are the products of medieval India, as an examination of the texts quoted will show; many of the southern authorities quoted can only be classed as modern. The increasingly hieratic art of medieval and modern India, especially in the south, is doubtless closely knit with this literary tradition. But the literary tradition is not the source of the art, for iconography presupposes icons.

Cheik Abu Said Abil-Khair

early 17th century
Gray wash, heightened with white watercolour on stock paper
border with green garland, a gold and blue pattern
and golden foliage, margin of sandblasted gold
11.1 x 6 cm; folio, 36 x 25 cm
Bibliothèque nationale de France, Paris

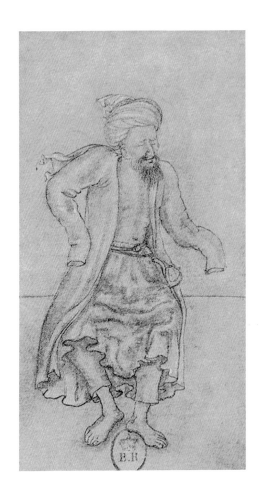

The technical formulae of the sastras resulted in a standardisation of production in spite of which genius, which knows no bonds, asserted itself. A further element is apparent in the recent discussion of Indian art. Aesthetically we are not at all concerned with the sub-continent that is known as India or its peoples, but our curiosity must be strong as to its past and future. The pageantry of Indian history is as glorious as that of any country in the world.

Qur'an

early 17th century
Cream paper and fine lacquer binding, 33.5 x 22 cm

Artistically it falls into two main periods, the first of which, ending with the Muslim conquest, is an epic in itself.

Traditions have died and the symbols that embodied them have died with them, but regret for the out-worn creed is ineffectual. New traditions and new symbols are surely in the making. Proteus and Triton have become empty names, but the sea remains. Nothing is lost but a dream, or rather the means of expressing a dream.

Crossing the Ganges by Akbar

Ikhlas and Madhou, c. 1600
33.4 x 20.1 cm
Victoria and Albert Museum, London

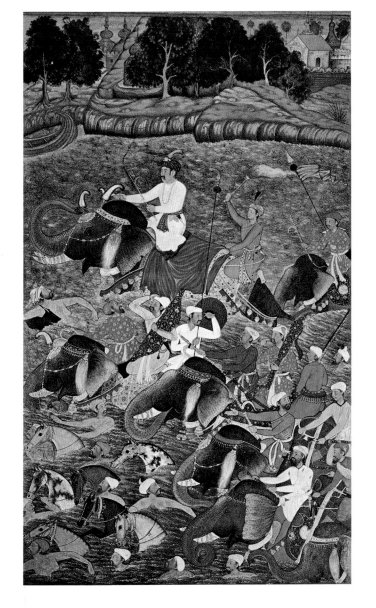

Indian religious history must be unfolded against a background of primitive conflict and superstition. The Vedas, in spite of their antiquity, cannot be accepted as the sole source of religious thought in India, or as anything but a critical and highly selective representation of this unvoiced and necessarily formless background. This relationship between Hinduism and the primitive, between the formulated philosophy of the schools and the worship and propitiation born of the vague fears and desires of masses, is present throughout the history of India,

Ornate façade of the Akbar Mausoleum (detail)

1600-1613, Akbar/Jahangir period
Black and white marble inlay, Sikandra, Agra, Uttar Pradesh

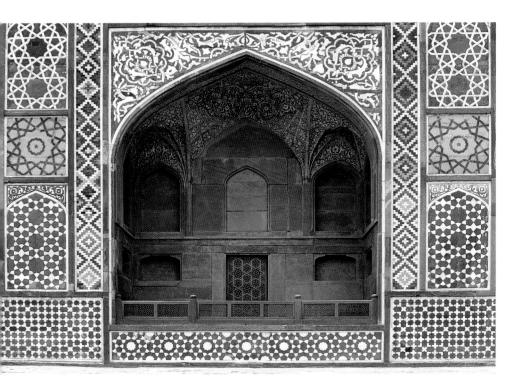

51

both religious and political. The Atharva Veda was not known to the early Buddhist writers but its practices and beliefs cannot be separated from the more altruistic and poetical polytheism of the less popular, more orthodox (but not more ancient) collections. In the same way the powers and manifestations of the *puranas* and epics are not necessarily modern because they do not appear in the Veda; in a sense they are more ancient, being native to the soil. Vedic thaumaturgy and

Dara Shikoh (?)

17th century
Opaque watercolour and gold, 15.4 x 8.8 cm
Bibliothèque nationale de France, Paris

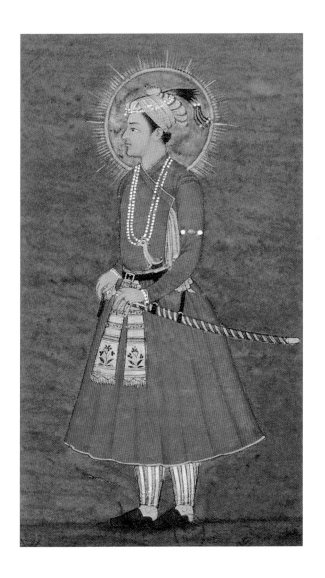

theosophy were never the faith of India. The countless mother goddesses and village guardians of the South lie closer to the real heart of Indian religion, a numberless pantheon, superficially identified with Hinduism but radically distinct and unchanged.

Among these lesser gods that keep their place on the fringes of the orthodox are to be found spirits of the earth and of the mountain; the Four Guardians Gods of the Quarters with Vessavana-Kuvera at their head; Gandharvas,

Rama and Lakshmana Meet
─────────────────────────

Page from a Manuscript of the *Ramayana*
Mysore variant of south Indian style
1600, Akbar period, Patan, Gujarat
Opaque watercolour and ink, 27.6 x 16.5 cm
Virginia Museum of Fine Arts, Richmond

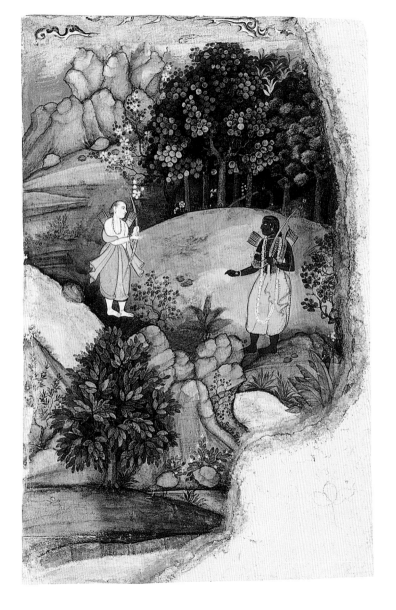

heavenly musicians; Nagas, the snake-people who have their world beneath the waters of streams, but who sometimes are identified with the tree spirits; and Garudas, half men-half birds who are the deadly foes of the Nagas. These diminished godlings must be regarded as the last remnant of a whole host of forgotten powers, once mighty and to be placated, each in its own place. Strange beings of another sphere, they could not wholly be passed over either by Hindu or Buddhist.

European Scene

1600, Akbar period, Patan, Gujarat
Opaque watercolour and ink, 33.5 x 20.8 cm
Virginia Museum of Fine Arts, Richmond

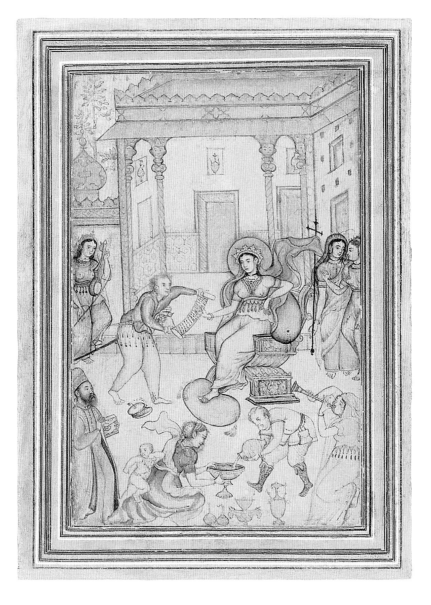

Vessavana-Kuvera appears on one of the pillars of the Bharhut railing, as does also Sirima Devata (goddess of fortune). The latter also received acknowledgement at the hands of the compilers of the Satapatha Brahmana who were forced to invent a legend to account for her existence. In the Taittiriya Upanishad she is again fitly mentioned in company with the moon and the sun and the earth. At Sanchi, she is to be recognized exactly as she is still represented in painted and gilt marble at Jaipur, seated upon lotus, lustrated by two elephants.

The Prophet Idris (Enoch)

c. 1600-1620, Akbar period
Opaque watercolour and gold, 19.5 x 12.5 cm
Bibliothèque nationale de France, Paris

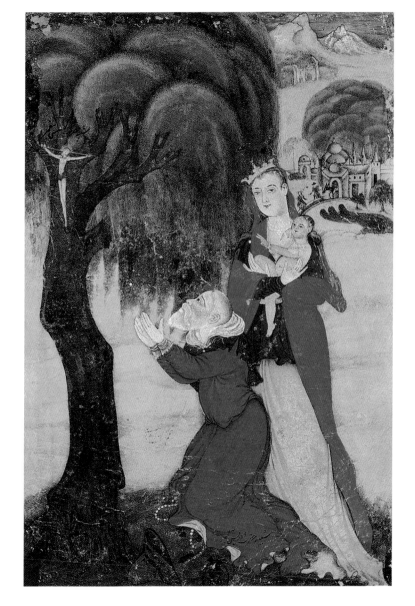

The Maha-samaya Sutta describes a gathering of all the great gods to pay reverence to the Buddha in the Great Forest at Kapilavatthu. Dhatarattha, king of the East, Virulhaka, king of the South, Virupakkha, king of the West, and Kuvera, king of the North arrive with their Yaksha host and all their vassals. The Nagas come from Nabhasa, Vesali, Tacchaka, and Yamuna, among them Eravana. Their enemies, the twice-born Garudas, too, are there and also the Asuras,

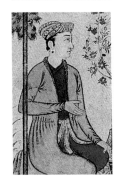

Prince with a snack

c. 1605-1610, Allahabad
Opaque watercolour and gold on stock paper, 18 x 10.7 cm
Bibliothèque nationale de France, Paris

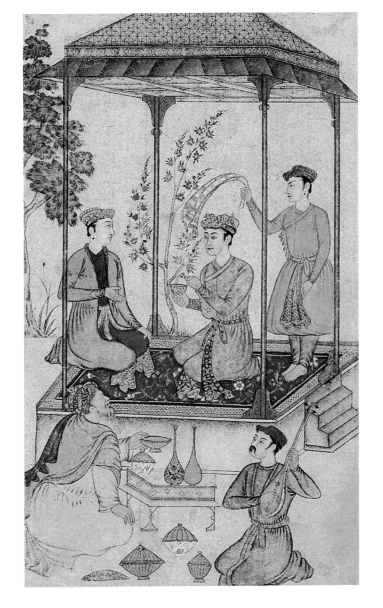

61

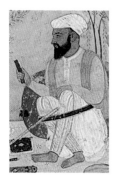

dwellers in the ocean. Fire, Earth, Air, and Water are present, and the Vedic gods, and lastly the powers of Mara (demon of temptation) who bids creation rejoice at his own defeat at the Buddha's hands.

Another list of the same description, but possibly earlier, is to be found in the Atanatiya. Both lists are, patently, the outcome of a priestly attempt to bring these hundred and one strange spirits and godlings within the sphere of Buddhist teaching,

Scholar in a garden,
surrounded by servants and musicians

1605-1610, Allahabad
Opaque watercolour and gold, 13 x 8 cm
Bibliothèque nationale de France, Paris

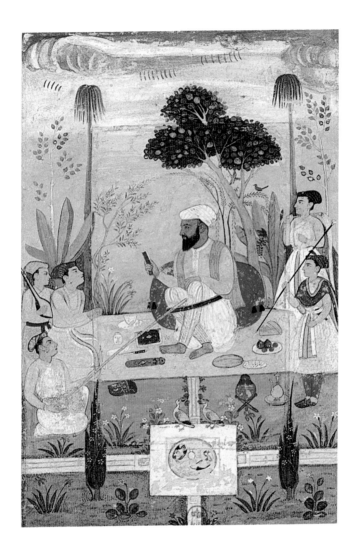

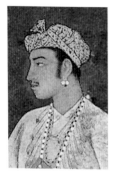

by representing them as gathered in hosts at the Buddha's feet. The group of Yakshas, Yakshinis, and Devatas carved upon the stone pillars of the *stupa* railing at Bharhut fulfil exactly the same function. They are manifestly earth-born and possess something of the delicate beauty of all forest creatures. They seem beneficent enough, but their manifestation here is admittedly chosen to serve Buddhist ends. Like all primitive powers, they are exacting in their demands and when neglected or provoked their anger is implacable and cruel.

Prince Khusrau hunting

Basawan or Manohar (?) (attributed to), c. 1606
Opaque watercolour and gold, 11.9 x 5.5 cm
Bibliothèque nationale de France, Paris

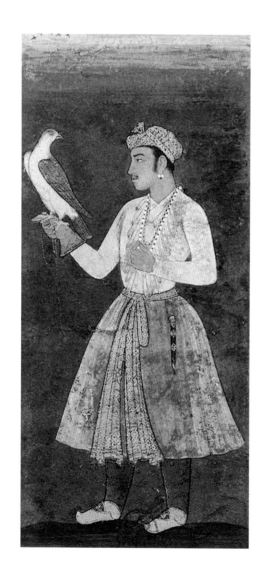

They are adorned with earthly jewels to represent the treasures they have in their gift, but are to be more closely identified with the trees under which they stand and the forest flowers they hold.

This cult of trees and tree spirits has a long history. In the sculptures of the early period (2nd-1st century BCE) the Buddhas are represented only by symbols, among which are their distinctive trees. Gautama attained enlightenment seated beneath the Asvattha or pipal tree. In the Atharvaveda it is said that the gods of the third heaven are seated

Calligraphic album page
(Nasta'liq script)

―――――――――――

Abd al-Rahim, 1606-1607, Jahangir period, Lahore, Punjab
Opaque watercolour and ink, 34 x 22.2 cm
Virginia Museum of Fine Arts, Richmond

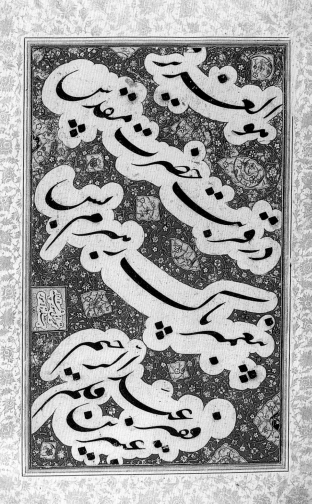

67

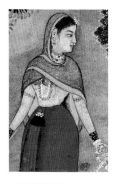

under the Asvattha and it may also be the "tree with fair foliage" of the Rigveda under which Yama and the blessed are said to pass their time. In the Upanishads, the tree spirits have definitely materialised. They, like all things, are subject to rebirth. If the spirit leaves, the tree withers and dies, but the spirit is immortal. In the Jatakas, these tree spirits play a great part, being worshipped with perfumes, flowers, and food. They dwell in many kinds of trees but the banyan seems most popular.

Kakubha ragini

c. 1610
Opaque watercolour, 15.9 x 11 cm
Bibliothèque nationale de France, Paris

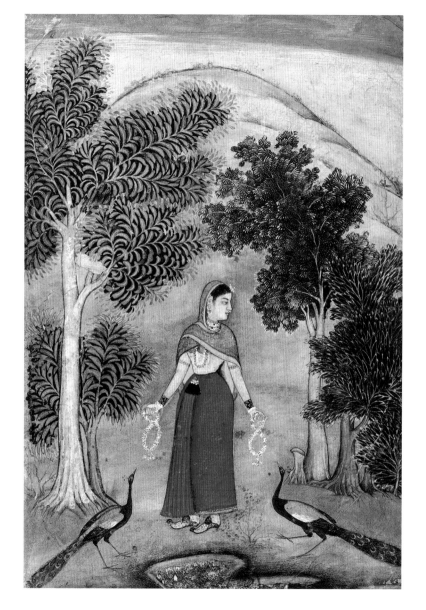

The scarlet-flowered silk-cotton tree and the sal tree as well as the pipal retain their sanctity today. The goddess of the sal is worshipped as giver of rain by the Oraons of Chota Nagpur, and in South Mirzapur the Korwas place the shrine of Dharti Mata under its branches. In the Jatakas more than once animal and even human sacrifices are spoken of in connection with tree worship. Today the slaughter of roosters and goats is added to the more usual offering of flowers and sweetmeats, in extreme cases of propitiation.

Megha Raga

Page from a *Ragamala Series*, 1610
Opaque watercolour, 22.5 x 18.4 cm
Virginia Museum of Fine Arts, Richmond

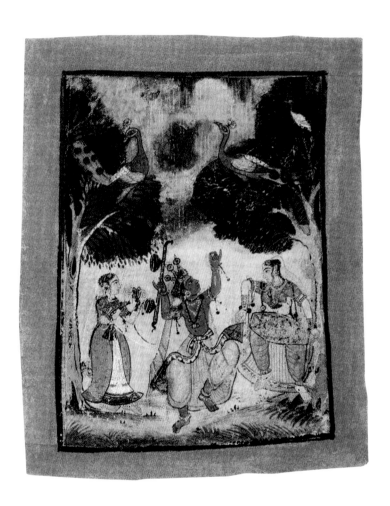

The character and functions of these deities correspond closely to those of the mother goddesses of Southern India. Among these are Mariamma, goddess of smallpox, Kaliamma, of beasts and forest demons, Huliamma, a tiger goddess, Ghantalamma, who wears bells, and Mamillamma, she who sits beneath the mango tree.

However, it is usually made plain that these are but different names for the one great goddess. In Hindu hands, this female pantheon appears as the Ashta Sakti or eight female powers.

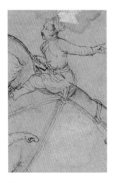

Fight of two elephants

Farrukh Chela (attributed to), c. 1610-1615
Gray wash, 16.9 x 26.8 cm
Bibliothèque nationale de France, Paris

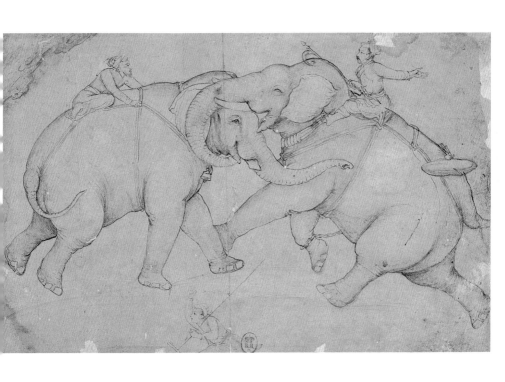

But a more primitive group is that of the Sapta Kannigais or seven virgins, tutelary deities of temple tanks. In Mysore, too, a similar group of seven sister goddesses, vaguely identified with the Shivait mythology is found. However, they and all the mother goddesses are distinguished from the true gods of Hinduism by the fact that they are acknowledged to be local in their influence, warding off or inflicting calamities of various kinds, but strictly limited in their sphere of action. Still more limited are the powers of temple tanks,

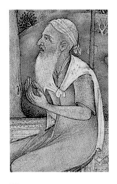

Assembly of six Muslim doctors

Manohar (attributed to), from a dispersed Manuscript of the *Gulistan* of Saadi, c. 1610-1615 Opaque watercolour, 8 x 12 cm Bibliothèque nationale de France, Paris

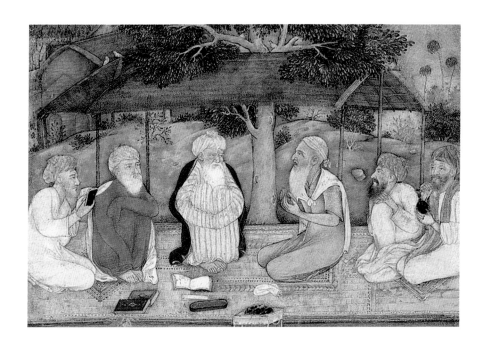

trees, and groves which periodically are alternately propitiated and exorcized, but are, as a whole, unsubstantial in personality and short lived.

It is against this complex background of creed and culture that Indian philosophy and Indian art, and all things Indian, must be viewed. Here lies philosophy, the origin of the lovely treatment of flower and fruit at the hands of Indian sculptors and painters, and also of the imagination that kindled their vision and gave such dynamic power to their designs.

Akbar goes hunting

c. 1610-1620, Jahangir period
Opaque watercolour, gold, and silver, 18.6 x 10.4 cm
Bibliothèque nationale de France, Paris

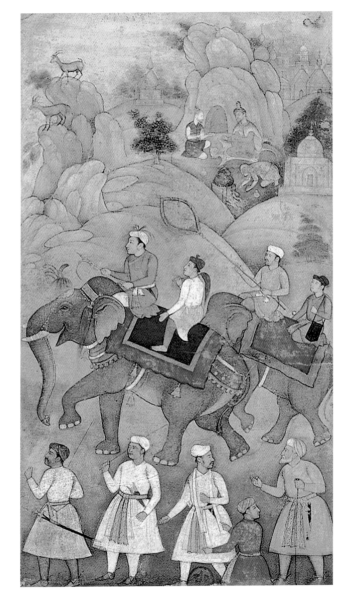

Indian philosophy begins with Vedic speculations, or rather questionings as to existence and the creation. The unformulated philosophy of the Upanishads sprang from these and from it the pantheistic Vedanta system was evolved. As a foil to this existed from early times the atheistic Sankhya system, upon the reasoning of which Buddhism and Jainism were founded. At the root of everything lies the unseen (*adrishta*), that is, the acceptance of metensomatosis and a cycle of existences (*samsara*)

Persian on a hunt

c. 1610-1620
Opaque watercolour, orange border with gold chevrons, margin with pink flowers, 21 x 12 cm; folio, 30 x 20 cm
Bibliothèque nationale de France, Paris

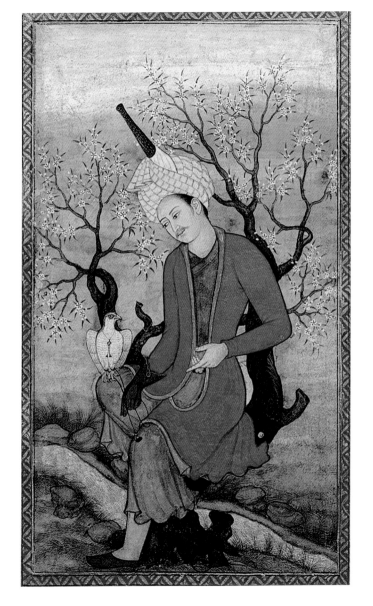

79

modified only by action (*karma*). At the root is ignorance (*avidya*). From ignorance comes desire, which leads to action, so the wheel revolves within the wheel. The Vedanta doctrine from the Upanishads taught the absolute identity of the individual soul with that of the universe: "That is the Eternal in which space is woven and which is interwoven with it... There is no other seer, no other hearer, no other thinker, no other knower..." From this identification of the mortal,

Indian dignitary, perhaps Raja Suraj Singh

c. 1615
Opaque watercolour and gold, 11 x 6 cm
Bibliothèque nationale de France, Paris

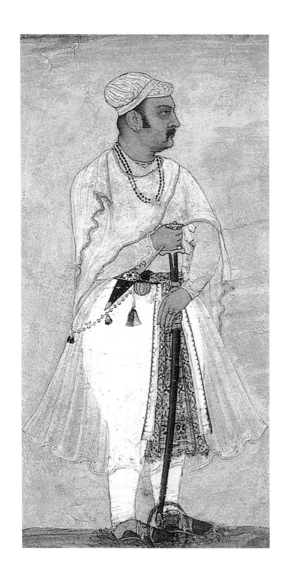

limited self with the eternal and universal sum of all things arose the idea of the illusion (*maya*) of the world of sensual experience. Only when the illusion of experience ceases, as in dreamless sleep, can the lesser self reunite with the universal self. This implied duality is in fact itself an illusion. Desire and action are inherent in such an illusion and the consequence is *samsara*. But knowledge disperses the illusion. Whoever knows this: 'I am Brahma',

Persian noble and musician

c. 1615-1620
Opaque watercolor and gold on stock paper, 17.6 x 15 cm
Bibliothèque nationale de France, Paris

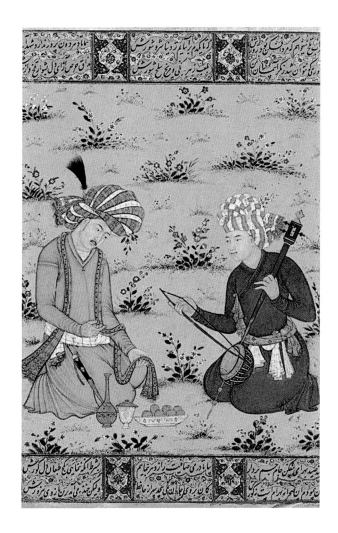

becomes the All. Even the gods are not able to prevent him from becoming it, for he becomes their Self.

The Sankhya system is atheistic and dualistic, admitting matter and the individual soul as eternal but essentially different. In the absoluteness of this division lies release. The soul, being removed from all matter, ceases to be conscious, and the bondage to pain (in which pleasure is included) is ended.

Persian falconer

c. 1620-1630
Opaque watercolour and gold, 15.3 x 7.3 cm
Bibliothèque nationale de France, Paris

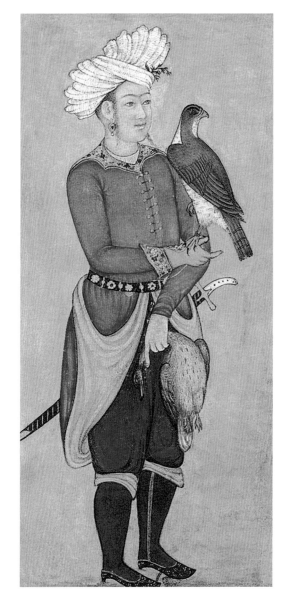

Both Buddhism and Jainism presuppose the existence of the Sankhya philosophy. But it is evident that the sixth century BC, when both Gautama and Vardhamana lived and taught, was a period of extensive mental activity of an extremely sophisticated kind. The Brahmajala Sutta mentions Eternalists, Non-Eternalists, Semi-Eternalists, Fortuitous originists, and Survivalists, and also certain recluses and Brahmans who, as dialecticians, are typified as "eel wrigglers".

I'timad-ud-Daulah Mausoleum

1622-1628, Jahangir period
White marble, semi-precious stone decorations
and pietra dura inlay
Agra, Uttar Pradesh

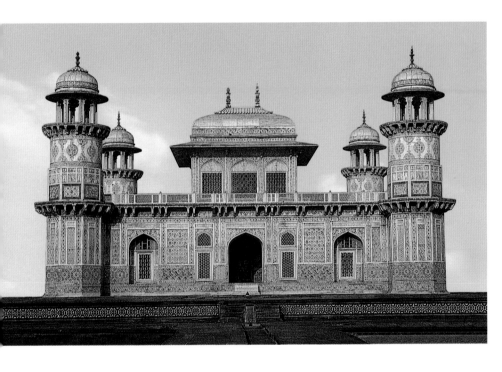

Buddhism is as much in revolt against this mental complexity as against the ritual complexity of the Brahman priest-craft. With regard to generalities its position is agnostic. The Three Marks of Impermanence, Pain, and Lack of Individuality must be considered as a practical summary of the characteristics of life. Upon these the doctrine of the Four Noble Truths, the essence of Buddhism, is founded: suffering exists; ignorance and desire are its causes; release is possible; the means are the Eight Points of Doctrine – right knowledge,

Ornate façade of the I'timad-ud-Daulah Mausoleum

1622-1628, Jahangir period
White marble, semi-precious stone decorations
and pietra dura inlay
Agra, Uttar Pradesh

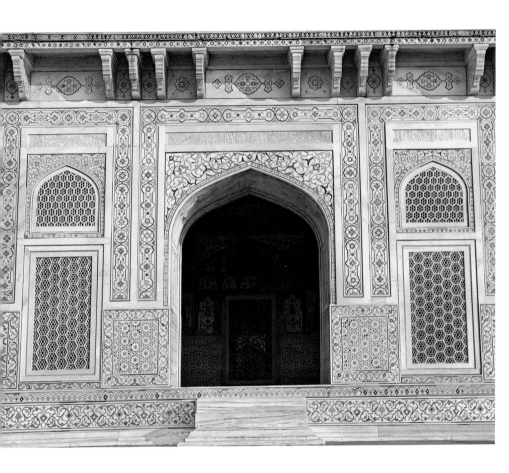

right aspiration, right speech, right conduct, right living, right endeavour, right mindfulness, and right meditation. Throughout the teaching uncertain, empirical opinion (*ditthi*) is set apart from true wisdom (*panna*). Above all, the cultivation and regulation of the will is stressed in an entirely new way.

Lastly, as against the changing, foundationless illusions of the unregulated personal life in a universe that can only be described in terms of change,

Three red tulips

c. 1625-1630
Opaque watercolour, border of red and gold threads
red paper margin, 11 x 7.6 cm
Bibliothèque nationale de France, Paris

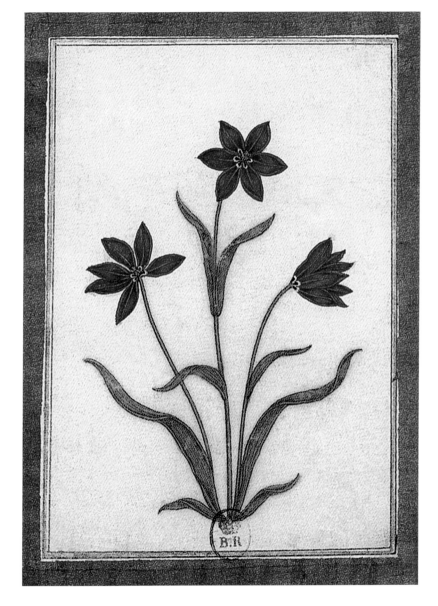

91

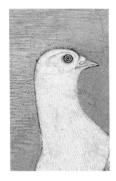

the Buddhist doctrine (*dharma*) is held out as being well-founded in time or rather in human experience. It is described as an ancient well-trodden path, a claim that paves the way to the conception of not one Buddha but many Buddhas. At Bharhut and Sanchi the seven Buddhas of the canon are all found, symbolized by their respective trees.

This doctrine of wise renunciation was preached by Gautama, a prince of the Sakya clan, who renounced his worldly heritage in pursuit of truth.

Couple of imperial pigeons

c. 1620-1630
Opaque watercolour and gold, 21.7 x 14.3 cm
Bibliothèque nationale de France, Paris

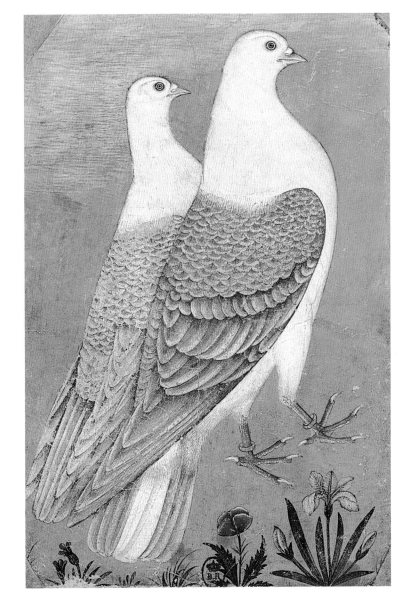

93

Much of the adverse criticism which Buddhism has been subjected to has been due to a misunderstanding of *nirvana*, the goal of all Indian speculation. Buddhism has had a complex history. Divided into two main sects, that of the Theravada and that of the Mahayana, and changed beyond recognition, it exists no longer in the land of its origin. The Jain faith preached by Vardhamana, a contemporary and therefore rival of Gautama, still persists in India. He, too, was of the Kshattriya caste, and renouncing his birth-right,

Two butterflies on grass

Fathullah (?)
Opaque watercolour, border with beige garland
and golden leaves, 13.7 x 9 cm
Bibliothèque nationale de France, Paris

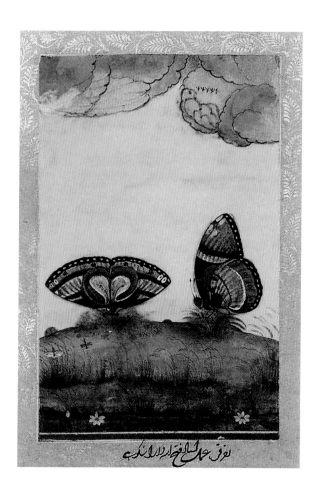

eventually attained Wisdom, appearing as the leader of the Nirgrantha ascetics. According to Jain tradition, Vardhamana, or Mahavira, as he came to be known, was the twenty-fourth of a series of *jinas* or conquerors of the world. Like Buddhism, the Jain faith opposes the exclusiveness of Hinduism by a claim to universality. Like Buddhism, it is founded upon the teaching and achievement of Right Faith, Right Knowledge, and Right Action. However, unlike Buddhism,

Purple and white flower

c. 1625-1630
Opaque watercolour, blue paper border, 13.8 x 8 cm
Bibliothèque nationale de France, Paris

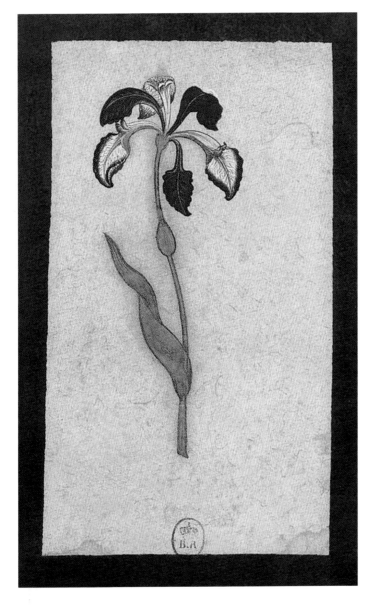

asceticism is greatly stressed even to the point of voluntary death by the refusal of nourishment on the part of those who have attained the highest knowledge, the *kevala jñâna*. From an early date two Jain sects have existed, the Digambara, who regard nudity as indispensable to holiness, and the Svetambara or "white-clothed", who do not. Besides these two bodies of ascetics, the faith is extended to a large body of laity, who are represented in the history of Indian art, by many sculptures dedicated in the Kushan era, and by the magnificent medieval temples at Mount Abu,

A Mughal Prince

1625-1630
Opaque watercolour and ink, 23.7 x 21.3 cm
Virginia Museum of Fine Arts, Richmond

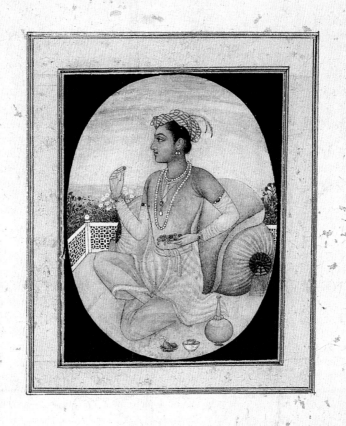

Girnar, and Satrunjaya. Like the Buddhists, the Jains founded many monasteries. The worship of stupas was also included in their rites.

The cult of the Upanishads and its forest-dwelling adherents is described in the Aggañña Sutta:

> They making leaf-huts in woodland spots, meditated therein. Extinct for them the burning coal, vanished the smoke, fallen lies the pestle and mortar; gathering of an evening for the evening meal,

Ram

———

c. 1625
Opaque watercolour and gold
border with blue garland and golden leaves
orange-red margin with golden flower seedlings
13.1 x 17.6 cm; folio, 32.5 x 29 cm
Bibliothèque nationale de France, Paris

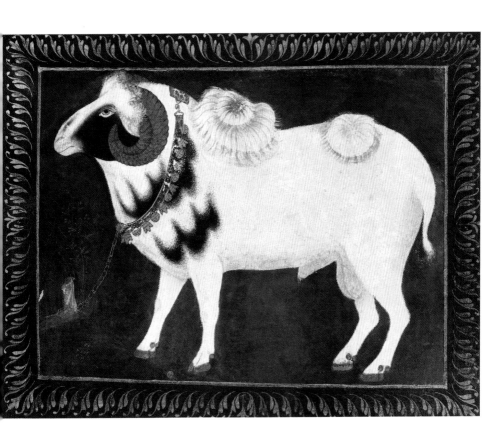

they go down into the village and town and royal city, seeking food. When they have gotten food back again in their leaf-huts they meditate.

But from forest life and meditation many sank to a mendicant life on the outskirts of the towns and to being mere repeaters of the sacred books. Such were the Hindus of the Buddha's day.

Modern Hinduism is divided into two main cults, Vaishnavism and Shaivism. From the point of view of Indian art the early period is almost entirely Buddhist,

Flowers of two colours, blue and red

c. 1625-1630
Opaque watercolour, border of red paper, 13.3 x 8.5 cm
Bibliothèque nationale de France, Paris

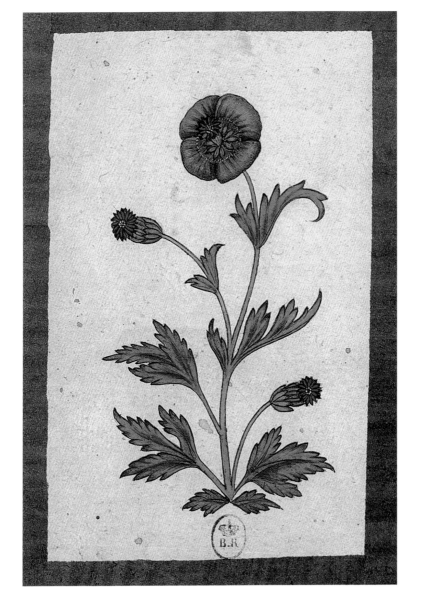

while the Gupta period, and the succeeding medieval period are Hindu, the sculpture of the latter period being radically based upon Hindu iconography.

Rudra, the storm god of the Vedas, is made known by many epithets. He is called Girisa (lying on a mountain), Kapardin (wearer of tangled locks), and Pasupatih (lord of cattle). When appeased he is known as Sambhu or Samkara (the benevolent), and as Shiva (the auspicious), but he remains lord of the powers of the universe and is to be feared as well as loved. Yet the element of *bhakti*, of

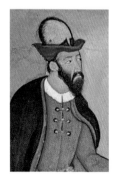

Two Portuguese during conversation
<hr>
c. 1630
Opaque watercolour and gold, 17.6 x 10.5 cm
Bibliothèque nationale de France, Paris

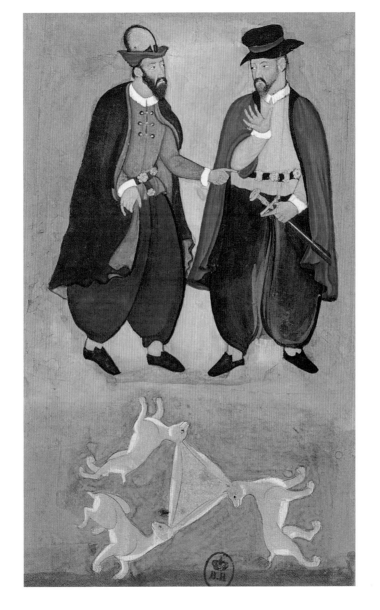

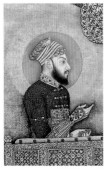

personal adoration and willing self-surrender to the deity, is not wanting in the worship of the Great Lord as unfolded in the later Upanishads.

In a lesser aspect Shiva is "lord of spirits" (*bhutas*) and his rites are connected with snake worship. In his worship the central object is the phallus. The Shiva linga does not seem to have been known to Patanjali, nor does it appear on the coins of Wema-Kadphises on the reverse of which the god is represented, holding the trident,

Bahadur Shah I (?) on an elephant

Detail of a page from an unknown manuscript
17th century
Opaque watercolour, 29.6 x 24 cm
Bibliothèque nationale de France, Paris

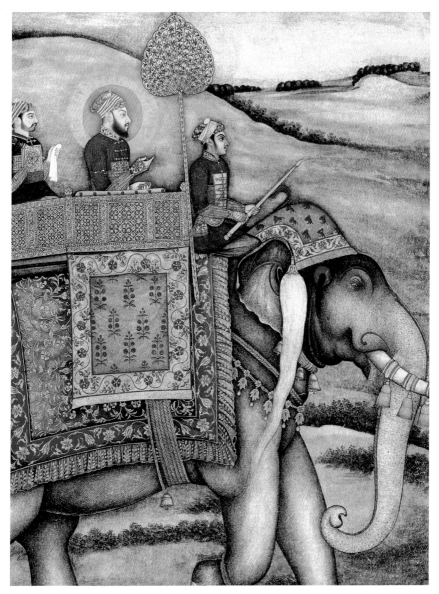

107

with the bull, Nandi, in the background. In the Mahabharata, Shiva is represented as dwelling in the Himalaya with his hosts. His vehicle is the bull and his consort is variously known as Uma, Parvati, Durga, and Kali. Having completed the creation, he turned yogi and the phallus became his emblem.

The earliest lingas existing do not pre-date the Kushan period. They are of the kind known as Mukha-lingas with one or more faces at the top of the member.

Muslim women in prayer

c. 1630-1640
Opaque watercolour and gold, 10.7 x 7.8 cm
Bibliothèque nationale de France, Paris

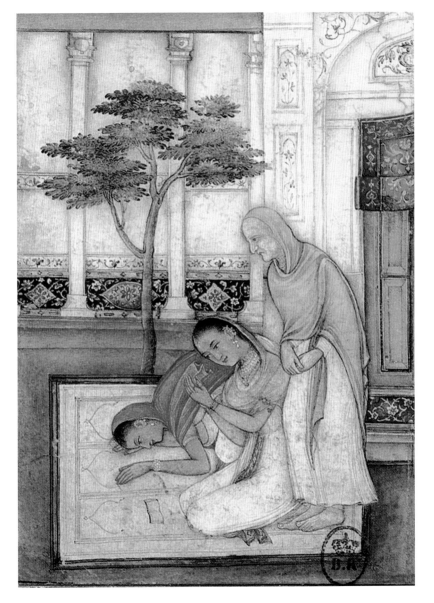

109

One of the earliest iconographical representations of the god is the Dakshinamurti (Guru-Shiva) in relief on one side of the Vishnu Temple at Deogarh which may be dated in the second half of the fifth century CE.

The earliest historical records of Vaishnavism are the Besnagar Heliodora inscription and the Ghosundi inscription, both of the second century BCE. The former testifies to the erection of a Garuda pillar to Vasudeva, god of gods. Heliodora, who was the son of Diya and a native of Taxila,

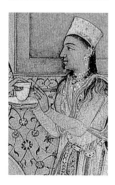

Indian princess surrounded
by her attendants and musicians

Bishan Das (or Bishandas) (attributed to), c. 1630-1640
Opaque watercolour and gold on stock paper, 15.2 x 8.8 cm
Bibliothèque nationale de France, Paris

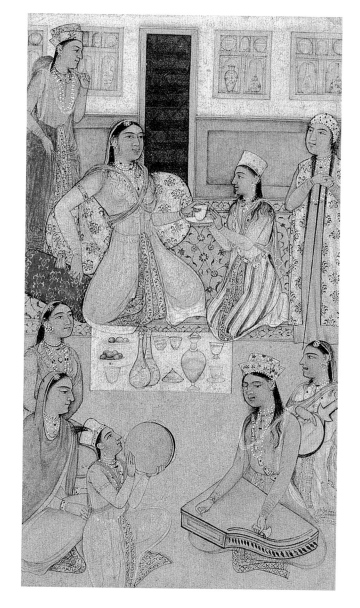

111

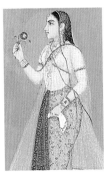

was ambassador from the Yavana Antialkidas to Bhagabhadra. He calls himself Bhagavata. The Ghosundi inscription witnesses to the erection of a hall of worship to Samkarshana and Vasudeva.

Vishnu is a Vedic deity and although he is represented by but few hymns, his personality is vividly portrayed. He measures all things with his three wide strides, the third passing beyond human discernment to the high places of the deity. This conception of the third step of Vishnu as the highest heaven and goal of all things, had obviously much to do with his elevation as the supreme being.

Portrait of a Mughal Lady

c. 1630, Shah Jahan dynasty, Patan, Gujarat
Opaque watercolour, 33.2 x 21 cm
Virginia Museum of Fine Arts, Richmond

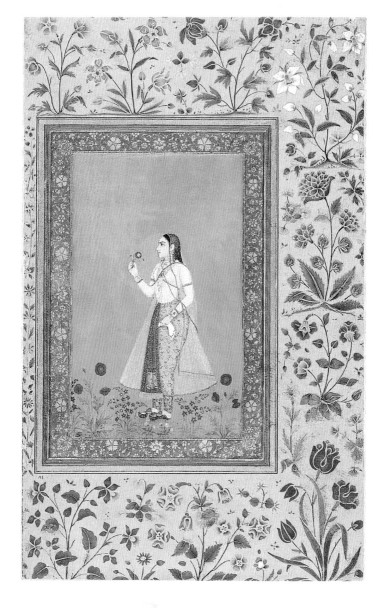

113

In the Mahabharata this Supreme Being is addressed as Narayana, Vasudeva, and Vishnu.

Later Vishnu found a more intimate place in popular worship by means of his ten incarnations (*avataras*).

Unlike Buddhism and Jainism, the Hindu sects are not organized into Hindu definite congregations. Whatever the shrine be, one of the magnificent temples of Bhubaneswar or Khajuraho, or a red daubed stone by the roadside, the worship is individual. For certain ceremonial purposes the aid of priests is sought,

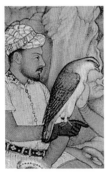

Humayun and
his brothers in a landscape

—————————

Fathullah (?) (attributed to), c. 1630-1640
Opaque watercolour and gold, 19 x 10 cm
Bibliothèque nationale de France, Paris

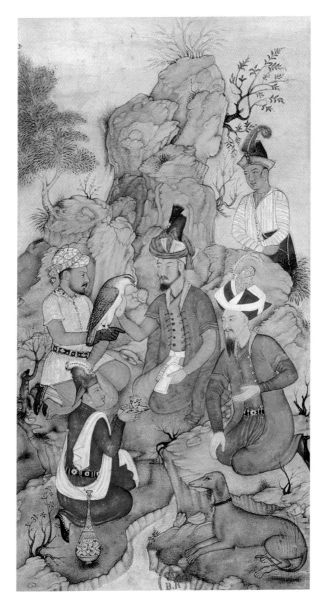

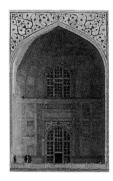

and all the larger temples have their hosts of attendants. But there is never a congregation worshipping in unison. Architecturally speaking, the Hindu shrine is the dwelling-place of the god, although various pavilions or porches dedicated to the preparation of the offerings or to music and dancing stand before it.

As portrayed in the Brahmajala Sutta, primitive Buddhism gave no place to aesthetics; music, song, and dance were classed with sorcery and

Taj Mahal

1638-1648, Shah Jahan period
White marble, jasper, jade, crystal, turquoise
lapis lazuli, sapphire, carnelian, etc.
Agra, Uttar Pradesh

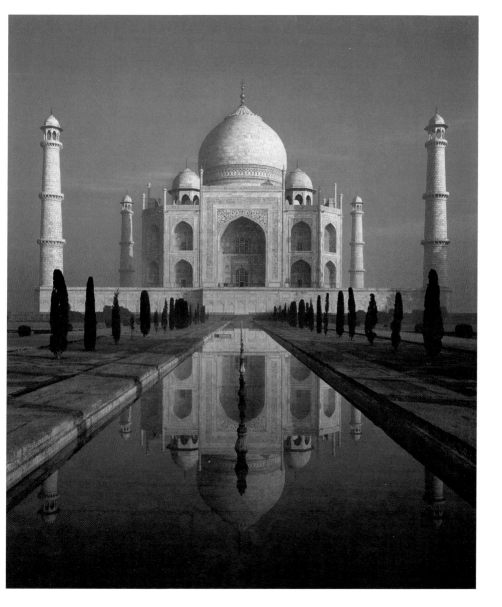

iconography, unprofitable to the wise. Manu and Chanakya also adopted this slighting attitude towards the arts. However, that is of little account, and Bharhut and Sanchi are not less fine because they are not supported by the argumentative analysis of the schoolmen. The art of the Early Period is a spontaneous growth, endued with native virility. Essentially narrative, it is vividly perceptive. The history of Indian art must be written in terms of the action of a literary,

Two travellers in landscape

Mirza Nadir Das, after an etching by Gillis van Scheyndel
c. 1640
Opaque watercolour, 10 x 14.4 cm
Bibliothèque nationale de France, Paris

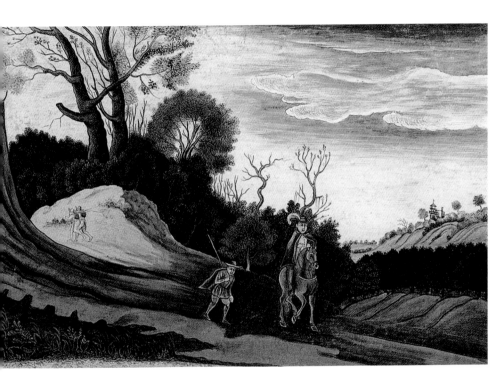

metaphysical mode of thought upon this naive, story-telling art, resulting in the formation of an immense and intricate iconography. Around this iconography has grown a still more abstruse, secondary literature, in which the least variation of detail is seized upon to sanction the subdivision and endless multiplication of types of icons.

Images are roughly divided into two classes, the fixed and the movable (*achala* and *chala*). They are likewise roughly described as standing (*sthanaka*), sitting (*asana*) or reclining (*sayana*).

Composite elephant preceded by a *div* (demon)

c. 1650
Opaque watercolour and gold on stock paper, 9.5 x 14.5 cm
Bibliothèque nationale de France, Paris

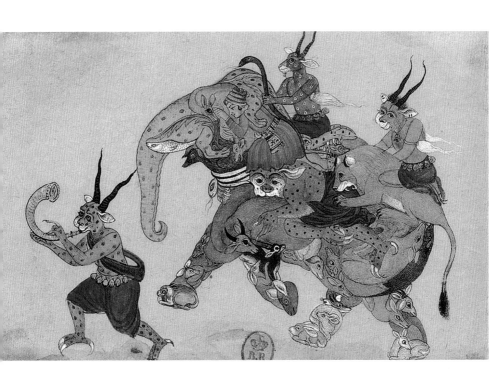

121

Also they may further be described in terms of the nature of the manifestation: as terrible (*ugra*) as is Vishnu in his man-lion incarnation, or pacific (*santa*). The images of Vishnu are further classified according to their natures as Yoga, Bhoga, and Vira, to be worshipped respectively according to the personal desires of the worshipper.

This classification of gods and devotees according to their innate natures refers directly to the classification by natures of the Sankhya philosophy,

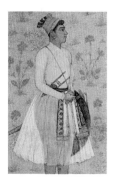

Ram Singh of Amber

Page from the *Late Shah Jahan Album*, c. 1650
Opaque watercolour and ink, 37.6 x 27.3 cm
Virginia Museum of Fine Arts, Richmond

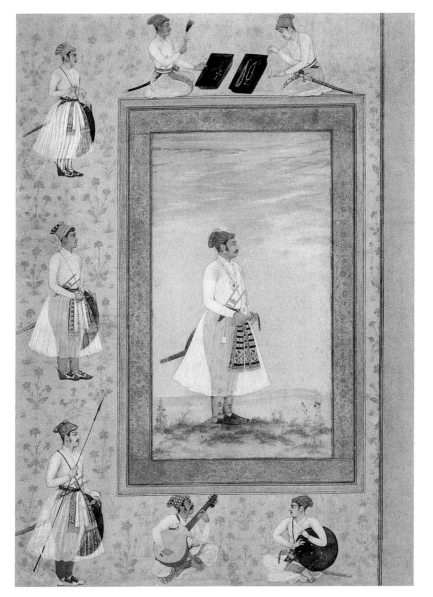

primeval matter being distinguished by the three properties (*gunas*) of light (*sattva*), mutation (*rajas*), and darkness (*tamas*). It is clear that the needs of the worshipper specify the type of the image worshipped. Complex manifestations, whose many attributes are symbolized by their many hands are considered Tamasic in character, and their worshippers of little understanding. To the wise, images of all kinds are equally superfluous.

European lady

c. 1650
Opaque watercolour, 5.2 x 3.9 cm
Bibliothèque nationale de France, Paris

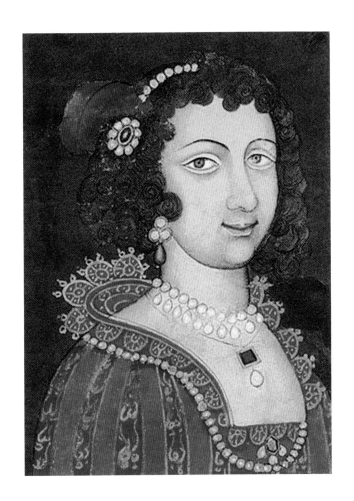

Indian aesthetics must be regarded as being of late date, a supplement to aesthetics, the iconographical literature of the medieval period. Much of the Agamas is of great iconographical interest, but these late literary canons have no aesthetic light to shed, although they do indicate something of the religious, hieratical atmosphere which deadened artistic creation in the last period of medieval decadence. Indian aesthetics are based upon the conception of aesthetic value in terms of personal response or reproduction.

Emperor Shah Jahan holding an iris

According to Hashim (?), c. 1655
Opaque watercolour and gold, 17.6 x 10.4 cm
Bibliothèque nationale de France, Paris

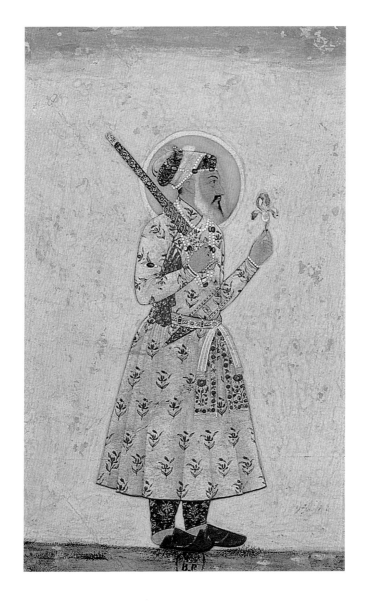

This value is known as *rasa*, and when it is present the object is said to have rasa and the person to be *rasika* or appreciative. Rasa produces various moods in the rasika varying in kind according to the initial stimulus; from these moods emotions spring. The mechanics of this system is worked out in detail in the Dhanamjaya Dasarupa and the Visvanatha Sahitya Darpana. The whole system is based upon and illustrated by literature, and cannot be applied directly to sculpture and painting.

Imperial Firman of the Emperor Aurangzeb

dated April 1661, Aurangzab period
Opaque watercolour and ink, 91.5 x 45.1 cm
Virginia Museum of Fine Arts, Richmond

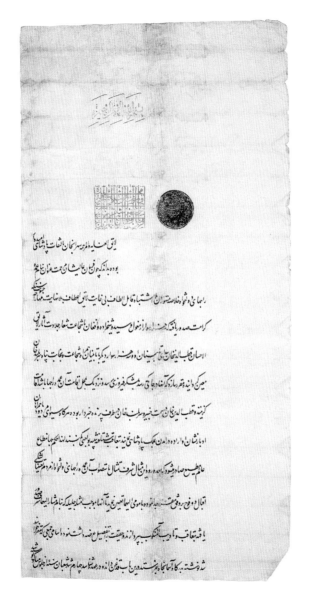

بسم الله الرحمن الرحيم

لايق اهل به هاويه سرانحان الطاف پادشاهي

بوده باآنكه جون فيض عايشان جهت هوان خاج

راهها يى وشوا خلاصه نوان اشتباه قابل الطاف بى نهايت لايق لطف بانهايت معها

كرامت صده وبا يكه هسنا ا از نهوا ي سبنده وشخواه وتفغان شحامت شحا جدادت شا آثار لتق

الاسار قطب الانحان عايى حسبان وهسنا سوار دكى بانيان شجاعت وغايت پناه خطر خان

معين كربايده وقدر مازد كا نغاد حاجى سدشكر فيروزى سه ونزد يكى جعل اقامت آمج راهها شتا

كزبده وقطب الدين بهست نجيره وسلمان جان طوف بژ ده خدرا بوده مركه سياوى ديوا

او با زشان وا ارده ادن جك پادشاهى ند تجاست مانى شه وكحكى سند لداله جهان طبع

عالم طبع صا دروشود واروان نمال شوف نمال با تصلوب آمج راهها يى وشوا از نهو دم شكى

افغال ونج بروقع جسه جداند وباموى سها فصح بدابآن ما وجب نشا خليك كزندا خام ثمار به حقى

يا شه شقاق وا دبسا آننگ بژ داز نده تهيت تفصيل صفه دشت نو دا سا ما جى كسهى

شونشته به كا آسانجا بژستند درين باب تحرى ا ده ده شا سه جام م شعبان سنه نحد

Mughal Painting

The history of Mughal painting begins with the name of Mir Sayyid Ali. In the year 1525, Babur set out upon the conquest of India, a land, however, which he did not regard highly. A few years later he was dead. In 1546 Humayun, his son, was deprived of his empire by the Afghan, Sher Shah, and until his final victory in 1555, existed as a landless refugee. One year of this period was spent at the Safavid court at Tabriz,

Durbar (court) of Shah Jahan
in Lahore where he receives Aurangzeb (detail)

c. 1670, Aurangzab period
Opaque watercolour and gold, 31.2 x 23.4 cm
Bibliothèque nationale de France, Paris

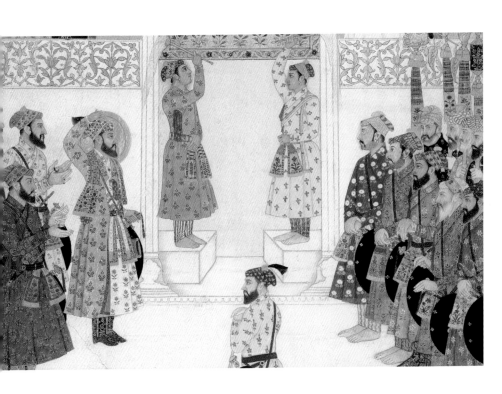

where Shah Tahmasp now ruled. Bihzad was dead, but the work of a young painter, Sayyid Ali, was already attracting attention. His father, Mansur of Badakshan, who was also a painter, was a contemporary of Bihzad's. Another painter of growing reputation also attracted the notice of the exiled emperor; this was Abdul Samad.

In 1550 both these artists joined Humayun's court at Kabul. Here, Mir Sayyid Ali was commissioned to supervise the illustration of *The Romance of Amir Hamzah* (*Dastan-e-Amir Hamza*)

Prince Muazzam Shah Alam hunting

c. 1670
Opaque watercolour and gold, 22.4 x 33.4 cm
Bibliothèque nationale de France, Paris

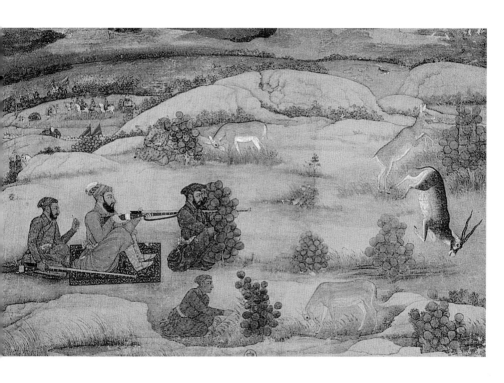

133

in twelve volumes of a hundred folios each. Sixty of these illustrations painted in tempera colours on prepared cotton cloth are in Vienna, and twenty-five of them in the Indian Gallery of the Victoria and Albert Museum and the British Museum. They must probably be attributed to the artists of the imperial court working under Mir Sayyid Ali, rather than to that painter himself. After Humayun's death Mir Sayyid Ali continued to work at the court of Akbar, and also performed the pilgrimage to Mecca.

Niccolò Manucci

1670
Opaque watercolour and gold
red brick margin with golden arabesque and
inscription: "NICCOLO MANVCCI", 36.5 x 26.5 cm
Bibliothèque nationale de France, Paris

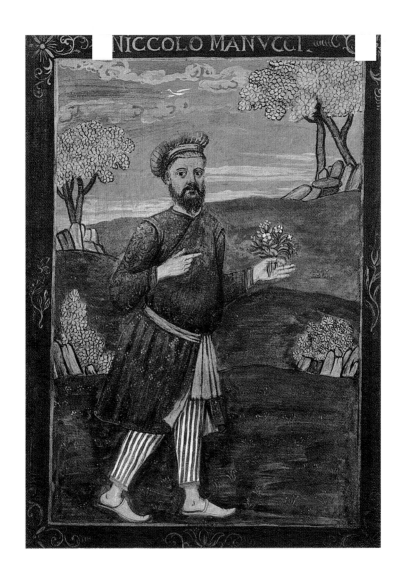

NICCOLO MANVCCI

The style of these early Mughal paintings is, of course, largely Safavid, but it is evident that modification and developments have already taken place. It is said that Bihzad added skill in portraiture to the art of painting; portraiture is further developed in Mughal painting. Also a greater use is made of relief and the range of colours is larger and more striking. There is something, too, about the use of flower and foliage that is un-Persian and wholly Indian. A certain

Azam Shah

An artist of Golconde (attributed to), from the Illuminated Manuscript the *History of India from Tamerlane to Aurangzeb* 1678-1686, Aurangzab period
Opaque watercolour, gold and silver, 31.5 x 22 cm
Bibliothèque nationale de France, Paris

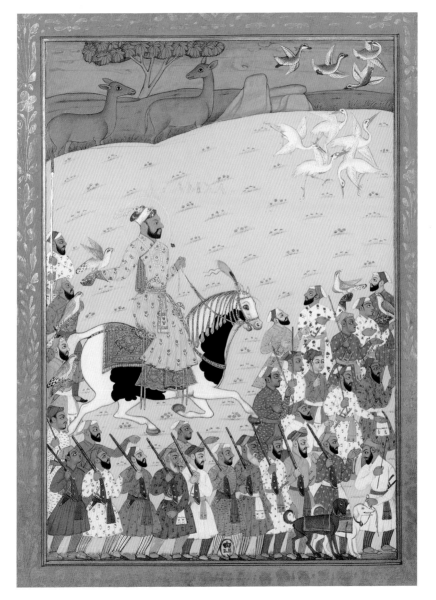

simplicity and breadth of design dominates the wealth of detail; the microscopic rendering of costume and accoutrements, textile hangings and architectural details is doubly delightful in so much as it is never obtrusive.

Such paintings on prepared fabric are common in India. It appears that paper itself was rare, or at any rate that large sheets were hard to obtain.

Summing up the technique and quality of early Mughal painting, it may be said that it was an offshoot of the Safavid school, the handiwork of artists trained in the school of Bihzad.

Madava Swooning Before Kamakandala (front)

Shiv Das, page from the *St Petersburg* (*Leningrad*) *Album*, 1700
Opaque watercolour and ink, 47 x 32.5 cm
Virginia Museum of Fine Arts, Richmond

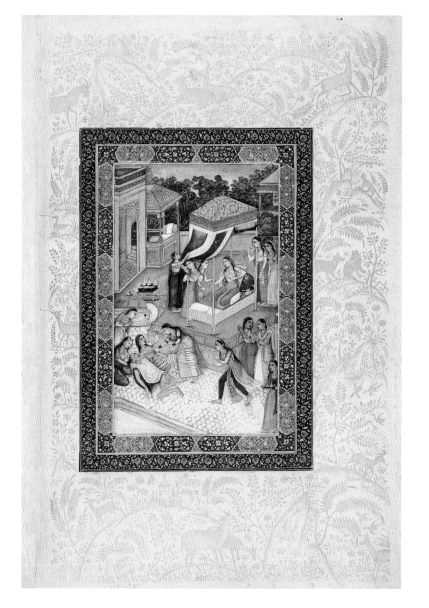

139

However, as has been said, the local character of the detail as shown in the portrayal of the Indian countryside and of its flowers and foliage is proof of complete acclimatization, promising vigorous development.

Akbar succeeded to the insecure throne of his father when still a boy with this distinction: that whereas Babur and Humayun were rulers in a foreign land, he was native born. The culture of his court did not merely reflect at a distance the splendour of Bukhara and Samarkand.

Madava Swooning Before Kamakandala (back)

Shiv Das, page from the *St Petersburg* (*Leningrad*) *Album*, 1700
Opaque watercolour and ink, 47 x 32.5 cm
Virginia Museum of Fine Arts, Richmond

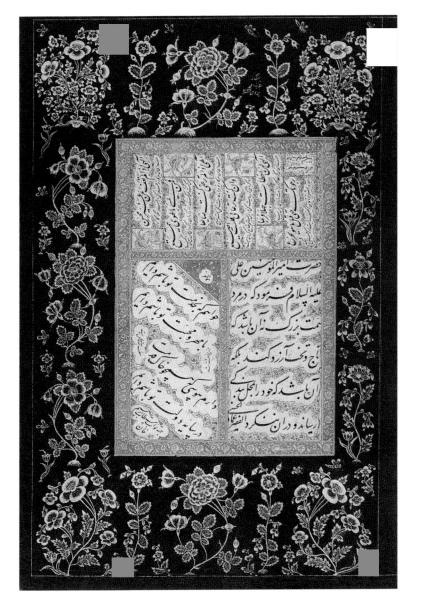

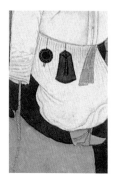

The building of Fatehpur Sikri in 1569 heralded a new era of Indian rule. And after the architects, masons, and sculptors had done their work, painters were called in to decorate the walls of the public halls and private apartments. It has been said that Mughal miniature-painting are little wall-paintings, a statement which tends to be confusing, since neither branch of Mughal painting has anything in common with the ancient Indian schools of painting of Ajanta and Gujarat,

Mullah Du Piyaza

18th century
Opaque watercolour and gold, 16.2 x 20.6 cm
Bibliothèque nationale de France, Paris

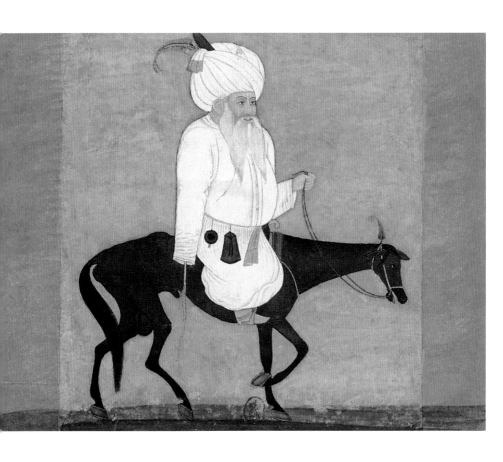

143

except certain inclinations to bright colouring and fine line-drawing which seem temperamentally inherent in Indian artists.

In Persia and India, as in China, calligraphy was regarded as a fine art worthy of the most serious study, and masters of it enjoyed fame throughout Asia like that of great painters in Europe. They were careful to sign and date their works, which were eagerly collected by connoisseurs. Abul Fazl gives a list of calligraphic experts, among whom in Akbar's time the most eminent was Muhammad

Women in the country under a mango tree

c. 1720-1740
Opaque watercolour, gold, and silver, 22.5 x 15.7 cm
Bibliothèque nationale de France, Paris

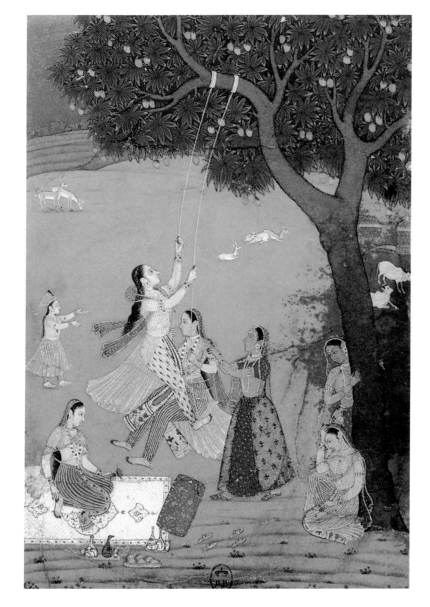

145

Husain of Kashmir, who survived the emperor for six years. Many of the albums in the London collections containing "miniatures" include hundreds of specimens of beautiful writing in various styles and of different periods, which often seem to have been more valued than the drawings and paintings associated with them. Abul Fazl enumerates eight calligraphical systems as current during the sixteenth century in Iran (Persia), Turan (Turkistan), India, and Turkey, distinguished one from the other by differences in the relative proportion of straight and

Muhammad Khan Bangash

c. 1730
Opaque watercolor and gold, red-gold border with fluted edges and white dots with red wash margin of golden foliage, 26.8 x 21.8 cm; folio, 32 x 45 cm
Bibliothèque nationale de France, Paris

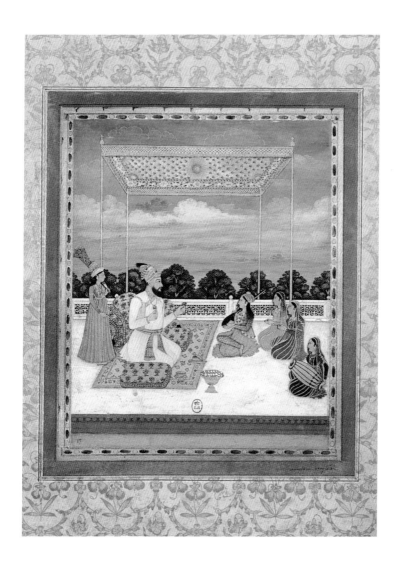

curved lines, ranging from the Kufic with five-sixths of straight lines to the Nastalik, Akbar's favourite script, with nothing but curved strokes. The forms of the Arabic alphabet used for writing Persian, although not distinctly reminiscent of pictorial hieroglyphs, as the Chinese characters are, lend themselves readily to artistic treatment, and even Europeans may understand to some extent the high technical skill of the masters of the calligraphic art, and admire the beauty of their productions.

Lord in a winter coat with his wife

c. 1730
Opaque watercolour and gold
blue border with golden floral garland framed in gilt
margin of iris seedlings and other blue flowers
oval, 8.6 x 6.7 cm; folio, 40.3 x 27.3 cm
Bibliothèque nationale de France, Paris

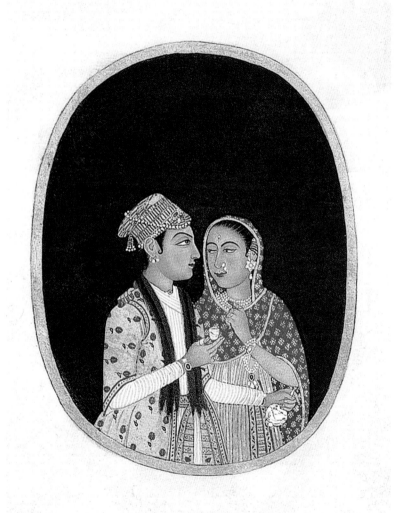

149

But full enjoyment and appreciation are possible only to persons familiar with the character from infancy and sensitive to all the associated ideas.

M. Huart sums up the close relations between calligraphy and Asiatic painting in the phrase: *En Orient la miniature n'est que la servante de la calligraphic.* The phrase, however, is not applicable to the ancient Hindu schools of painting, which, except in so far as they may have been influenced by Chinese and Persian ideas,

Addicts consuming *bhang*

c. 1735
Opaque watercolour, 20.2 x 28.7 cm
Bibliothèque nationale de France, Paris

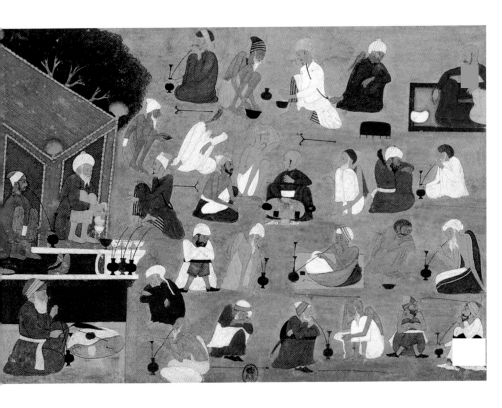

151

were independent of the scribe's art. None of the many varieties of the square Brahmi or Sanskrit script ever tempted the calligraphist to regard his manuscript as a picture, nor did anybody dream of collecting specimens of writing in that script merely for the sake of their beauty.

The rapidity with which the teaching of Abdul Samad and his Islamic colleagues was assimilated and then modified by scores of Hindu artists of various castes is in itself sufficient proof that the foreign teachers must have found trained indigenous scholars with whom to work.

Khosrow sees Shirin at the bath

Mir Kalan Khan (attributed to), c. 1735-1750
Opaque watercolour and gold, 31.5 x 22.3 cm
Bibliothèque nationale de France, Paris

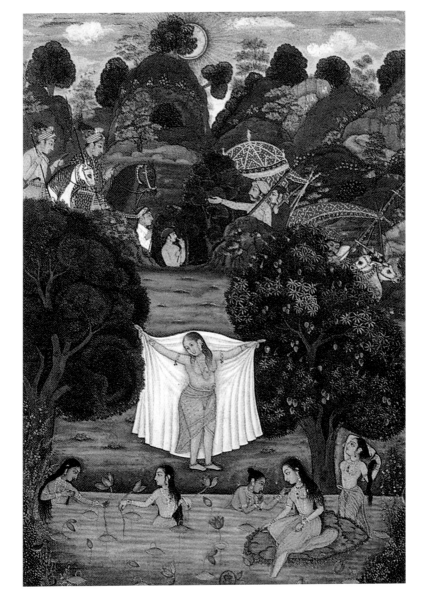

153

Men accustomed to draw and paint could easily learn new methods and a foreign style, but not even the despotic power of Akbar would have been able to create a numerous school of Hindu artists out of nothing.

This inference, inevitable from a general survey of the facts, is established with certainty by the positive testimony of Abul Fazl that Daswanth, who disputed with Basawan the first place among the Hindu painters of Akbar's court, had "devoted his whole life to the art, and used, from love to his profession, to draw and paint figures even on walls".

Young lord in his *zenana*

c. 1740
Opaque watercolour, gold, and silver, 32 x 23 cm
Bibliothèque nationale de France, Paris

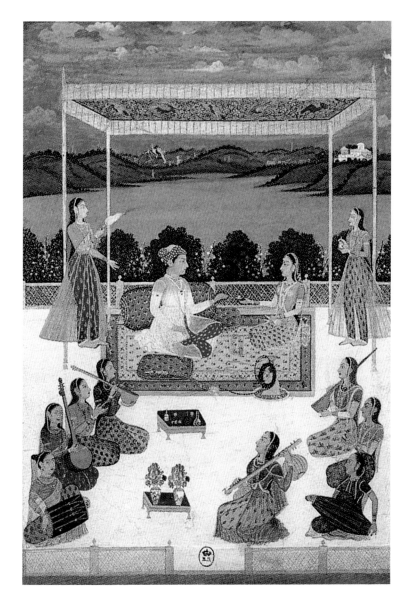

155

Abul Fazl goes on to say that the work of Basawan is so excellent that many connoisseurs preferred him to Daswanth.

The Qur'an, following the Semitic principle formulated in the Mosaic Second Commandment, absolutely forbids Muslims to make likenesses of anything in heaven or on earth; and the prohibition has been and is strictly obeyed, with rare exceptions, in all countries and at all times, so far as the decoration of mosques and other buildings

Elephant

Faqirullah Khan, c. 1740
Opaque watercolour and gold, 20.2 x 29.2 cm
Bibliothèque nationale de France, Paris

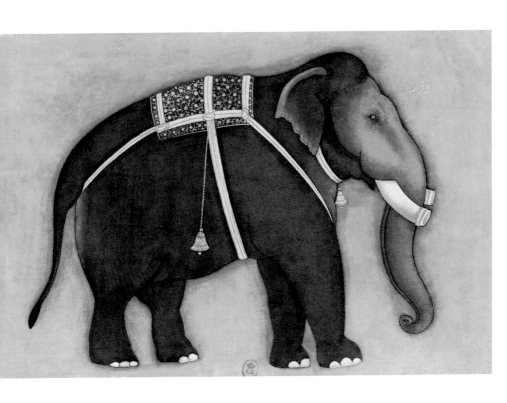

devoted to religious purposes is concerned. In book illustrations, however, such liberty is commonly assumed. The Mughal emperors of India looked to Iran for the graces of civilization, and it was natural that Akbar should desire to add the charms of Persian pictorial art to the amenities of his court. Regarding himself as Head of the Church and pontiff of a new religion, he cared little about the Prophet, and at a private party was heard by his Boswell to observe:

Horse

———

Faqirullah Khan, c. 1740
Opaque watercolour and gold, 23.2 x 29.2 cm
Bibliothèque nationale de France, Paris

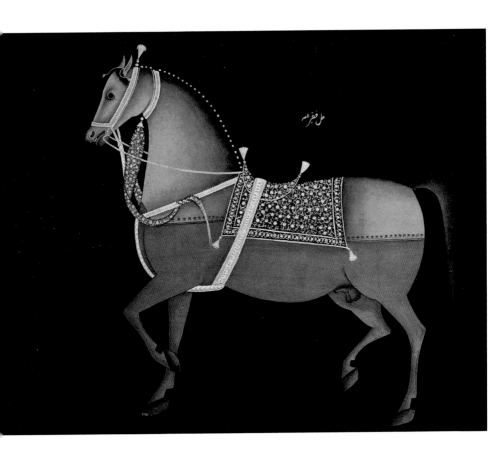

عمل فقير الله

159

There are many that hate painting, but such men I dislike. It appears to me as if a painter had quite peculiar means of recognizing God; for a painter in sketching anything that has life, and in devising its limbs one after the other, must come to feel that he cannot bestow individuality upon his work, and is thus forced to think of God, the Giver of life, and will thus increase in knowledge.

He found no difficulty in gratifying his taste. Liberal pay and abundant honour drew crowds of artists, both foreigners and Indians, Muslims and

Princess at her toilette

c. 1740
Opaque watercolour and gold, 23.6 x 16.1 cm
Bibliothèque nationale de France, Paris

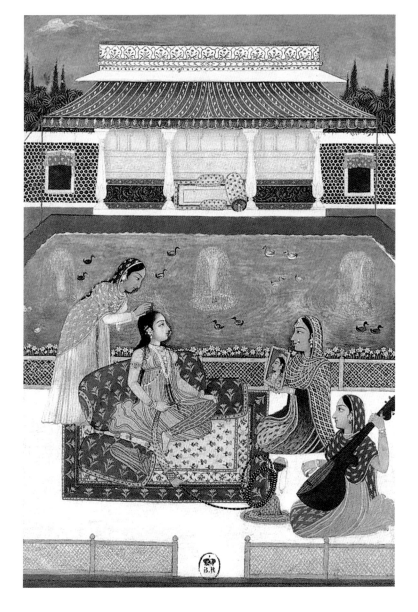

161

Hindus, to his magnificent court, where the more distinguished were enrolled as *mansabdars*, or members of the official nobility, and assigned ample salaries.

Imperial libraries of large extent were formed at Agra, Delhi, and other places stored with all that was best in Asiatic literature, both originals and Persian translations, the volumes being enshrined in the richest bindings, and adorned with miniatures regardless of expense. According to the Spanish priest, Father Sebastian Manrique,

Ladies on a terrace by the water's edge

c. 1750
Opaque watercolour and gold, 27.5 x 19 cm
Bibliothèque nationale de France, Paris

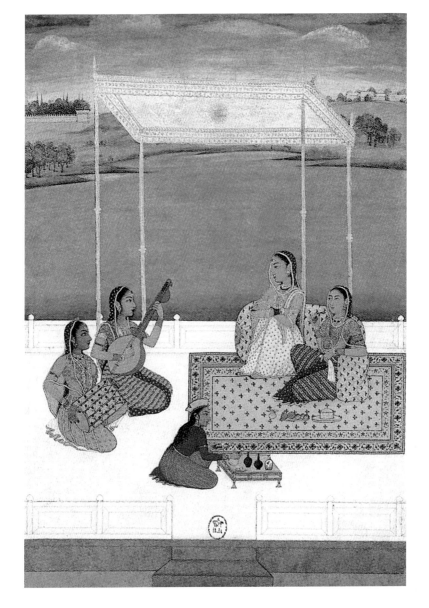

163

who was at Agra in 1641, the imperial library at that city contained 24,000 volumes, valued at an astounding sum.

The libraries thus formed were maintained and increased by Jahangir, Shah Jahan, and Aurangzeb (1605-1707); and even the weak successors of the last great mogul were not indifferent to the delights of choice books and dainty pictures. But the political convulsions of the eighteenth and nineteenth centuries destroyed the imperial libraries,

Aurangzeb at the siege of Satara

After Mir Kalan Khan, c. 1750
Opaque watercolour and gold, 34.5 x 26 cm
Bibliothèque nationale de France, Paris

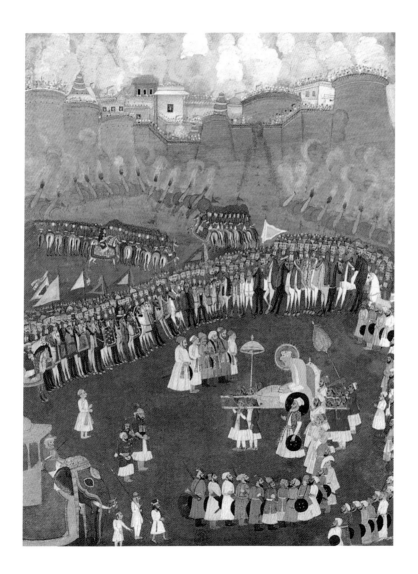

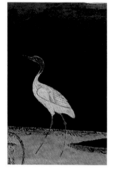

with most of the similar collections formed by subordinate potentates like the Rohilla chief and the Nawab-Wazir of Awadh. Fragments of these wonderful accumulations are now scattered over the world in private and public collections, and although constituting but a small fraction of the great mass once in existence, supply ample material for the history of Indo-Persian calligraphy and the sister art of the miniaturist. Many of these paintings have had adventurous histories.

Sheikh Saadi and Khwaja Hafiz

Follower of Dip Chand, c. 1750, Murshidabad
Opaque watercolour, 18.6 x 13.1 cm
Bibliothèque nationale de France, Paris

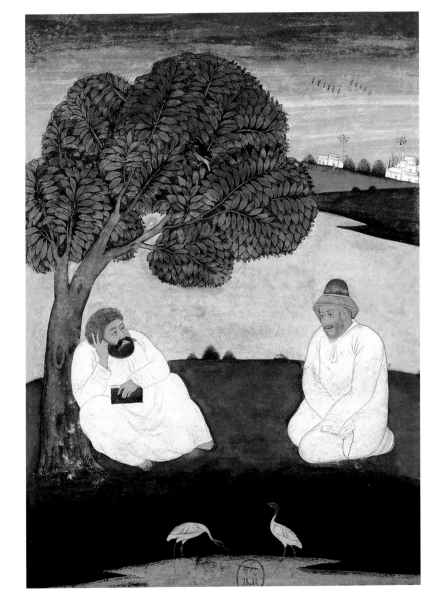

167

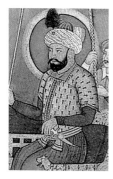

The illustration of manuscripts was only one form of Indo-Persian art, and that, as Blochet truly observes, was not always the most successful. The highest achievements of the Indian draughtsmen and colourists were often attained in separate pictures of varying sizes, which were frequently bound in albums, like that given by Dara Shikoh to his beloved wife. The British Museum collection includes many such albums, some of which, such as Hafiz Rahmat's volume, constitute historical portrait galleries of the deepest interest.

Bajazet brought before the Emperor Timur

c. 1750
Opaque watercolour, gold, and silver, 24.8 x 17.7 cm
Bibliothèque nationale de France, Paris

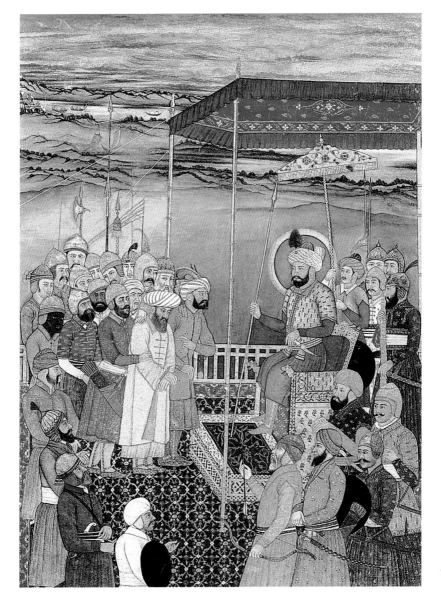

169

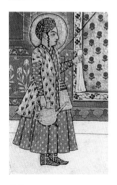

The fashion set by the court of Delhi and followed by all the feudatory courts and many individual nobles, was passed on to the wealthy English *Nabobs* in the latter part of the eighteenth century, who gladly seized opportunities of procuring specimens and bringing them home.

During the nineteenth century the taste for the work of the school was lost by both Europeans and Indians, and very few persons seemed to care what happened to the pictures, which were then procurable for nominal sums. According to Badaoni,

Yusuf arrives at Zulaikha

c. 1750
Opaque watercolour, gold, and silver, 24.8 x 16.2 cm
Bibliothèque nationale de France, Paris

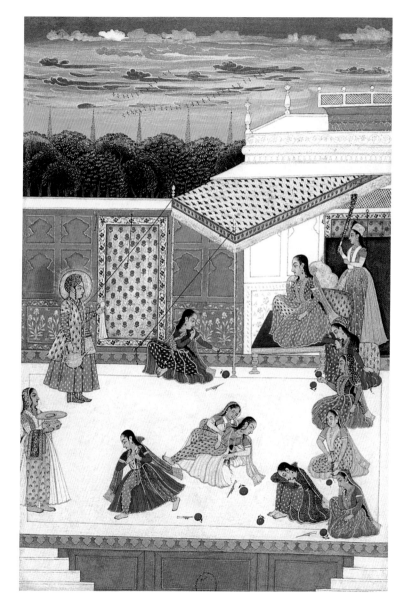

Akbar's hostile critic, the courtiers' taste for illuminated books had been stimulated in his time by a certain amount of compulsion, and it was natural that, during the "great anarchy" of the Maratha period, when the influence of the Delhi court sank to nothing, the amount of liberal patronage by the minor native courts should diminish. Nevertheless, even during those stormy times much meritorious portrait work was produced, and some good portraiture was executed as late as the nineteenth century.

Bhairavi regini
————————

c. 1750, Lucknow
Opaque watercolour and gray wash on stock paper
16 x 11 cm
Bibliothèque nationale de France, Paris

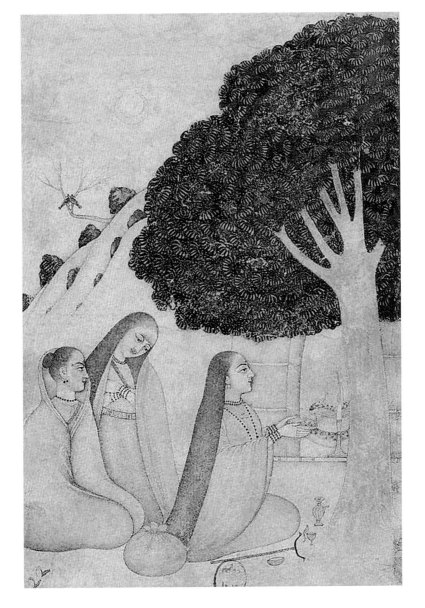

173

When François Bernier was writing to Jean-Baptiste Colbert the founder of the *Compagnie française pour le commerce des Indes orientales,* in 1669, early in the reign of Aurangzeb, who had the Puritan dislike for art, the position of artists had become much less favourable than that enjoyed by them in the days of Akbar, Jahangir, and Shah Jahan. The observant French physician, a thoroughly trustworthy witness, described as follows the relations between artists and their patrons, or rather taskmasters, as seen by him:

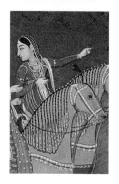

Baz Bahadur and Rupmati

Faizullah Khan, c. 1750-1760, Lucknow or Faizabad
Opaque watercolour and gold, 26.1 x 18.2 cm
Bibliothèque nationale de France, Paris

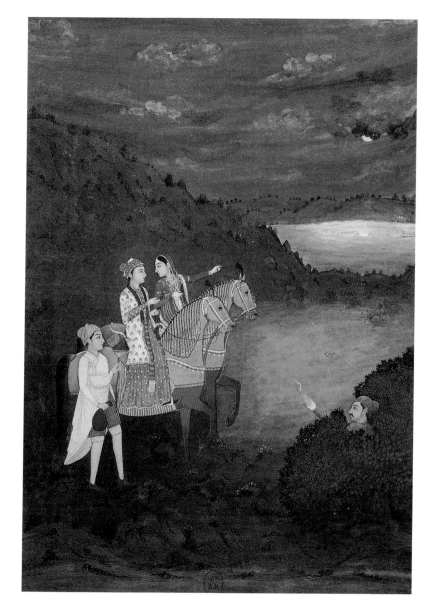

175

Can it excite wonder that under these circumstances [of general misery] the arts do not flourish here as they would do under better government, or as they nourish in our happier France? No artist can be expected to give his mind to his calling in the midst of a people who are either wretchedly poor, or who, if rich, assume an appearance of poverty, and who regard not the beauty and excellence, but the cheapness of an article; a people whose grandees pay for a work of art considerably under its value,

A Prince and his retinue hunting waterfowl

1750-1775, Murshidabad
Opaque watercolour, 31.8 x 24.4 cm
Virginia Museum of Fine Arts, Richmond

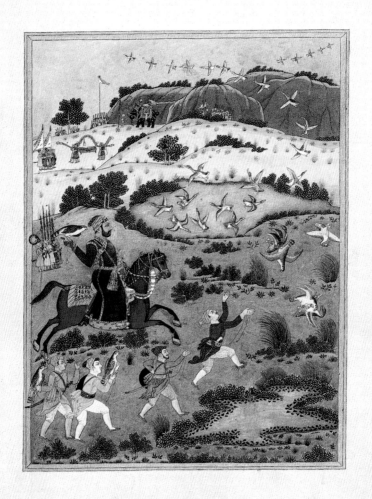

and according to their own caprice, and who do not hesitate to punish an importunate artist or tradesman with the korrah, that long and terrible whip hanging at every Omrah's [nobleman's] gate. Is it not enough to damp the ardour of any artist when he feels that he can never hope to attain to any distinction? … The arts in the Indies would long ago have lost their beauty and delicacy if the monarch and principal Omrahs did not keep in their pay a number of artists who work in their houses, teach the children, and

Nightlife scene in a royal *zenana*

Chitarman (also known as Kalyan Das), c. 1750-1760
Opaque watercolour and gold, 27.3 x 40.3 cm
Bibliothèque nationale de France, Paris

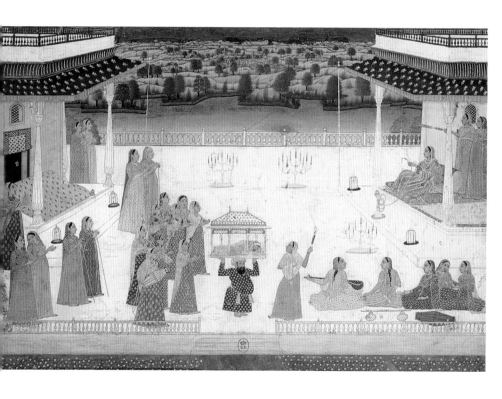

179

are stimulated to exertion by the hope of reward and the fear of the korrah.

Excepting the modern Delhi miniatures on ivory, the frescoes, the early paintings on cotton, and a few pictures on vellum, the Indo-Persian paintings are all executed on paper. I do not know any Indian examples of painting on silk in the Chinese manner. The Indo-Persian, like other Asiatic artists, conceived every object as being bounded by firm lines, and consequently, his first step was the drawing of an outline. For the illustration of ordinary Persian books,

Shuja Quli Khan on a terrace
in the company of a lady

c. 1755
Opaque watercolour, gold, and silver, 18.4 x 18 cm
Bibliothèque nationale de France, Paris

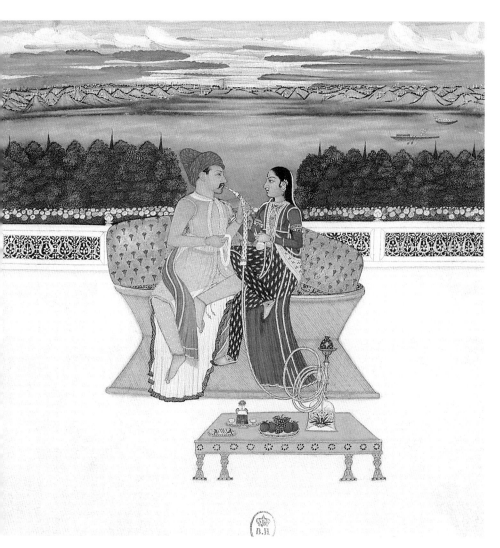

181

according to Blochet, the outline drawn directly on the page in red or black chalk was filled in with colours at once. For more costly and elaborate volumes the process was more complicated, the illustrations being executed upon a separate sheet subsequently applied to the blank space left in the manuscript. That sheet was first covered with a layer of very fine plaster, mixed in a solution of gum arabic. The outline was then drawn upon the perfectly smooth surface thus obtained, and opaque body-colours, mixed with water, were laid on in successive layers, just as in oil painting,

Nuns and musicians
———————————

Follower of Faqirullah Khan, c. 1760, Farrukhabad
Opaque watercolour and gold, gold and blue border
margin of sandblasted gold, 20.8 x 12.3 cm
Bibliothèque nationale de France, Paris

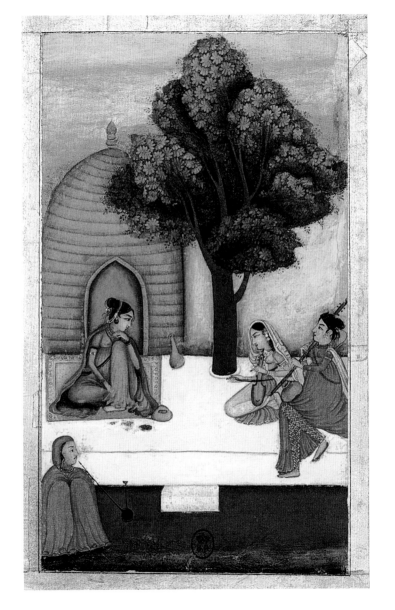

but with the difference that mistakes could not be rectified. Jewels and ornaments were indicated by needle prickings in sheets of gold-leaf, or even by the insertion of pearls or diamond chips. The work was all done by the Indian artists with fine squirrel-hair brushes, the most delicate strokes being executed with a brush of a single hair, an instrument requiring the utmost correctness of eye and steadiness of hand. The collections in London contain many examples of unfinished drawings and paintings, which, if examined critically by experts,

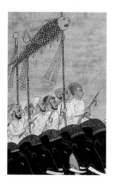

Caravan of elephants

c. 1755-1760, Murshidabad
Opaque watercolour and gold, 15.8 x 27.6 cm
Bibliothèque nationale de France, Paris

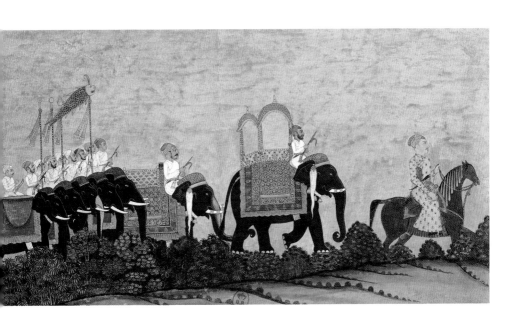

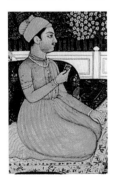

would fully reveal the Indian methods of work, and show how far they agreed with or differed from the Persian methods described by M. Blochet. It must be pointed out that portraits often exist in duplicate and triplicate.

The blue was ordinarily obtained from powdered lapis lazuli, imported from Badakshan, but indigo blues appear in early book illustrations of Hindu subjects. The reds used were cinnabar, vermilion, or cochineal. The yellow was chrome, and other colours were made up by mixing these.

Prince on a terrace surrounded by six women

c. 1760, Murshidabad (?)
Opaque watercolour and gold, 27 x 17.4 cm
Bibliothèque nationale de France, Paris

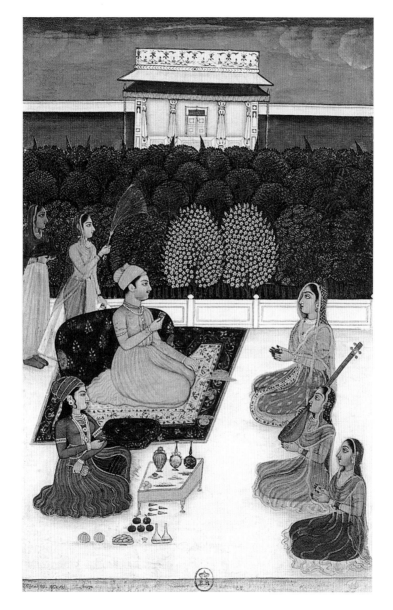

187

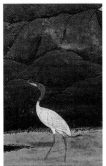

Gold was freely used in the form of gold-leaf, and also as a wash of which the Indians had the secret. The Persians applied an admirably transparent varnish made of sandarac and linseed-oil, mixed as a paste and dissolved in either petroleum or highly rectified spirits of wine. Probably the Indians used all the Persian appliances with some additions and modifications, but the ascertainment of full details would require special expert study and hardly repay the trouble.

Ibrahim Adham, Sultan of Balkh, served by five *houris*

c. 1760, Murshidabad
Opaque watercolour and gold, 22.2 x 15.8 cm
Bibliothèque nationale de France, Paris

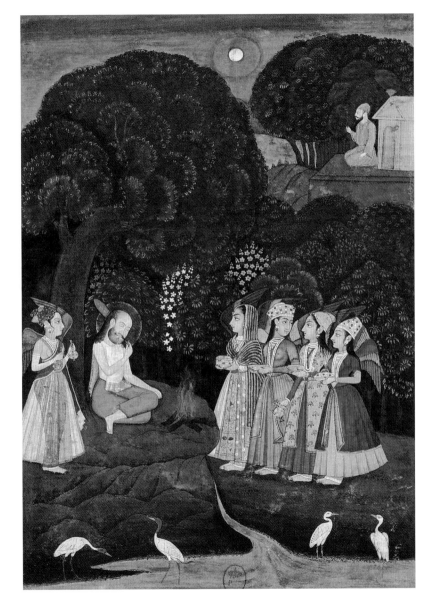

189

The practice of beginning a picture by laying down a firmly drawn outline led to a curious division of labour, the outline often being drawn by one man and the painting done by another. Sometimes four artists collaborated in one work. It is not clear how such a complicated arrangement was worked. The method, whether only two artists or four collaborated, necessarily tended to reduce their art to the level of a skilled mechanical craft; and, as a matter of fact, the mechanical nature of much of the fine Indo-Persian work is its greatest defect.

Swooning Madhava

Follower of Faqirullah Khan, c. 1760, Farrukhabad
Opaque watercolour, gold, and silver
30.2 x 19.2 cm
Bibliothèque nationale de France, Paris

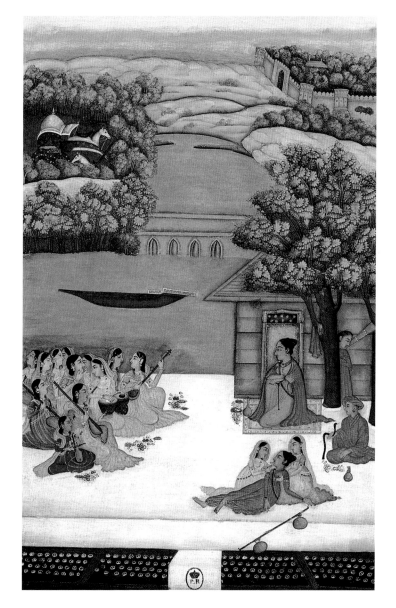

191

The early Indo-Persian book illustrations are wrought in excessively brilliant colours, chiefly red, yellow, and blue. As has been said they are avowed imitations or, rather, developments of Persian work.

In Persia, at the close of the fifteenth century, the character of Timurid art began to change, passing into the more delicate and sentimental style of the character in the sixteenth century. During the seventeenth century the refined Safavid style, with its lowered scale of colour, became familiar in India, where further local modifications were effected under the influence of Hindu tradition.

Princess led by her servants to the nuptial bed

Follower of Govardham II, c. 1760
Opaque watercolour and gold, 25.5 x 19.5 cm
Bibliothèque nationale de France, Paris

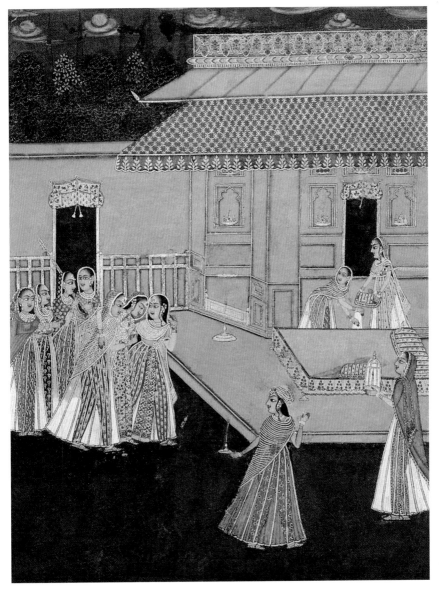

The Indian artists "had a truer feeling for colour and more sober tonality" than their Persian teachers, according to Blochet, who is disposed to think that the Indians sometimes carried the policy of softening colour to an undue extreme. They were wonderfully successful in their grisaille drawings of a single colour, frequently a pale sepia, with delicate gradations of tint, very pleasing to my eye. At the same time they developed a mastery over individual characteristic portraiture never equalled, I think, by the Persians.

Guru Arjan Dev on a horse

c. 1760, Faizabad
Opaque watercolour and gold highlights, 33.3 x 23.6 cm
Bibliothèque nationale de France, Paris

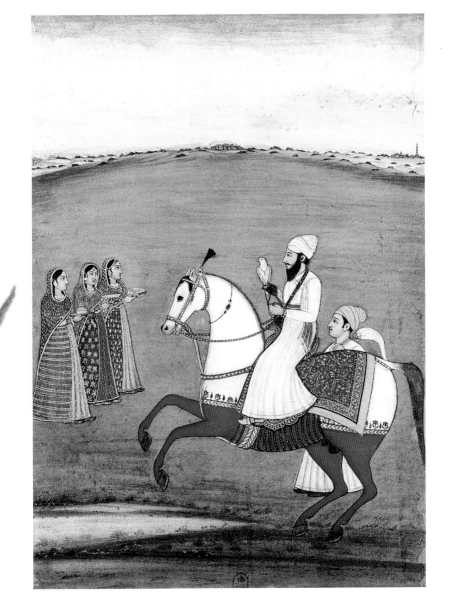

The best Indian work dates from the first half of the seventeenth century, but good portraits are to be found executed as late as the early years of the nineteenth century.

During Akbar's reign (1556-1605) and a portion of Jahangir's (1605-1627) the standing portrait figures are usually represented in profile in a formal, conventional manner, with the right hand holding up a flower or jewel, and the feet placed one in front of the other. Gradually this stiff formalism was dropped,

Yogi at the edge of a river
—————————————
Bahadur Singh (?) (attributed to), c. 1760
Opaque watercolour and gold, 22.7 x 15 cm
Bibliothèque nationale de France, Paris

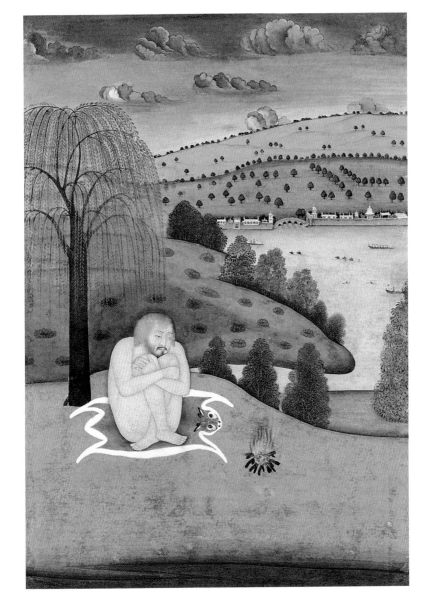

and men and women were drawn in natural attitudes. The more ancient Indo-Persian works, like their Persian models, follow unreservedly a style marked by the total lack of roundness, depth of tone, and aerial perspective, every object being represented as absolutely flat. During the later years of Jahangir's reign and subsequently, this flat style was modified by the Indian artists, who frequently introduced slight line shading with admirable effect, so contriving to give their figures a sufficient degree of roundness with wonderfully few strokes.

The voyage of Zulaikha (detail)

Bahadur Singh (?), painted in the Kashmir style
c. 1760, Lucknow
Opaque watercolour and gold, 30 x 22 cm
Bibliothèque nationale de France, Paris

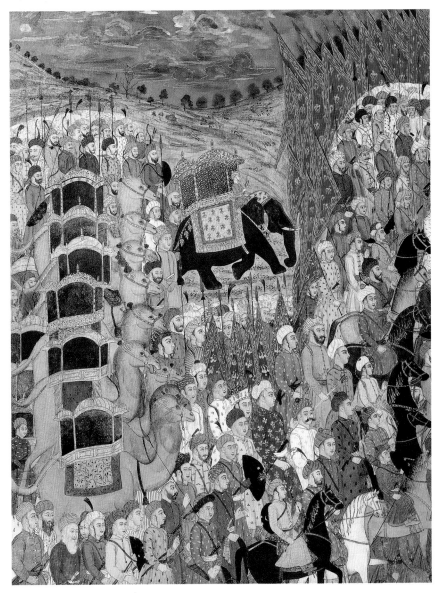

The change adds much to the attractiveness of seventeenth-century Indian work in European eyes, and was due to foreign influence. But chiaroscuro was imported to the detriment of colouring and line drawing. Delicacy and subtlety are bought at the cost of strength and vitality. Highly developed skill in portraiture seems to have swamped the sense of design and decoration. Foreign influence is also particularly noticeable in the treatment of clouds and foliage: such influence is often of a late eighteenth-century kind.

Cavalier Kathi

c. 1760
Opaque watercolour on indian paper, 24.7 x 18 cm
Bibliothèque nationale de France, Paris

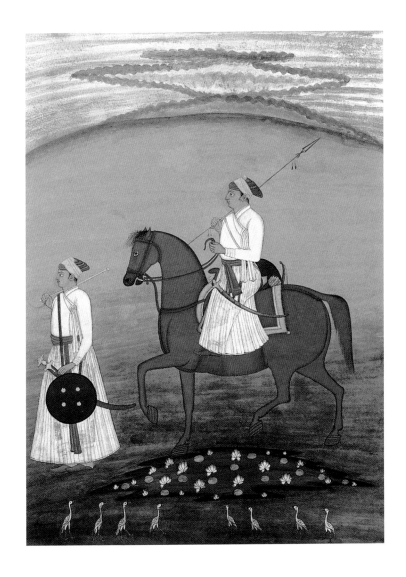

201

This improvement, if it may be so called, was the result of European influence which certainly became a potent factor in Persian and Indian art at that time. Most of the albums show it plainly. Biblical subjects were frequently treated by the artists, and were specially favoured by the royal family, who used them for palace decorations at both Fatehpur-Sikri and Lahore. Many other biblical subjects will be found in the collections, and it must be confessed that the pictures are not usually equal to those devoted to topics more congenial to the artists.

Muhammad awakened by the archangel Gabriel

c. 1760, Faizabad
Opaque watercolour and gold, 20.4 x 15 cm
Bibliothèque nationale de France, Paris

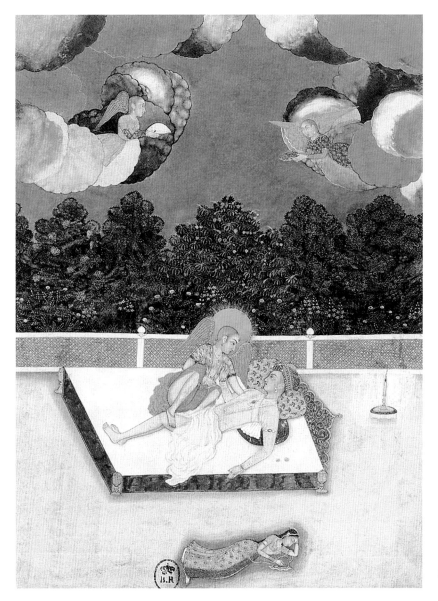

203

Many of the attempts to combine the methods of the West with those of the East are decided failures, as similar attempts in China have failed, but some few attain a high level of executive excellence.

The origin of such influence is not far to seek. The Persian kings admired European art, and deliberately sought to introduce its methods into their country. To this day the painters and illuminators of Isfahan, the earlier, and Tehran,

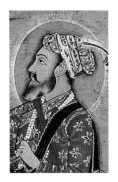

Shah Jahan hunting

c. 1760, Murshidabad
Opaque watercolour, gold, and silver, 23.4 x 15.3 cm
Bibliothèque nationale de France, Paris

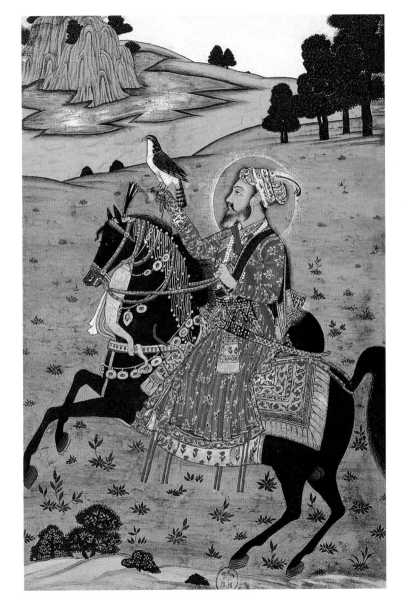

the later, capital of Iran, cherish as their ideal the ambition to "paint like Raphael", and pride themselves on their descent from certain of the students sent long ago to Rome who survived to return to the home of their fathers.

The Indo-Persian or Mughal school of drawing and painting having lived in considerable vigour from about 1570 to 1820 or 1830, a period, roughly speaking, of two centuries and a half and not being quite dead until the twentieth century,

Shah Madar surrounded by disciples

Perhaps Dal Chand, according to Mir Kalan Khan
c. 1760, Lucknow (or Faizabad, 1770)
Opaque watercolour and gold, 21.4 x 16.4 cm
Bibliothèque nationale de France, Paris

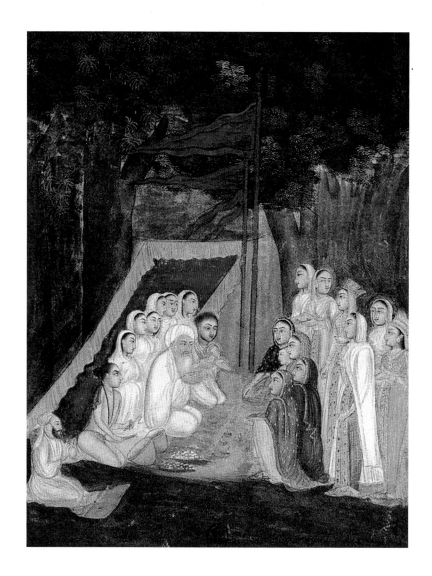

naturally produced an enormous output. The extant works, notwithstanding all the mishaps to which Indian art has been exposed, still can be numbered by thousands. Almost at the very beginning of the operations of the school, about the year 1590, when Abul Fazl, the minister of Akbar, wrote his memorable description of his sovereign's administration, a hundred artists were reckoned to be masters of their craft, while tolerable practitioners were past counting. During the reigns of Akbar's son and grandson,

Yusuf going to meet Zulaikha

Bahadur Singh (?) (attributed to)
painted in the Kashmir style, c. 1760, Lucknow
Opaque watercolour and gold, about 30 x 22 cm
Bibliothèque nationale de France, Paris

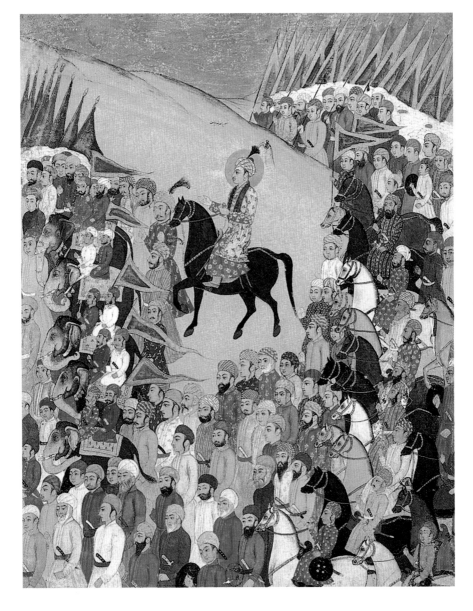

in the first half of the seventeenth century, when the new form of art grafted upon the stock of ancient Indian tradition attained its highest development, the number of proficients must have increased. Although the long-continued political and social agony which accompanied the decline and fall of the Mughal empire necessarily limited the opportunities for the practice of art and diminished its rewards, art did not die; a synthesis between Hindu tradition and Persian technique produced a new variety of Indian pictorial art possessing high merits. It is plain,

Shah Nimat ullah Wali

c. 1760, Murshidabad (or north Deccan)
Opaque watercolour and gold, 18.2 x 13.2 cm
Bibliothèque nationale de France, Paris

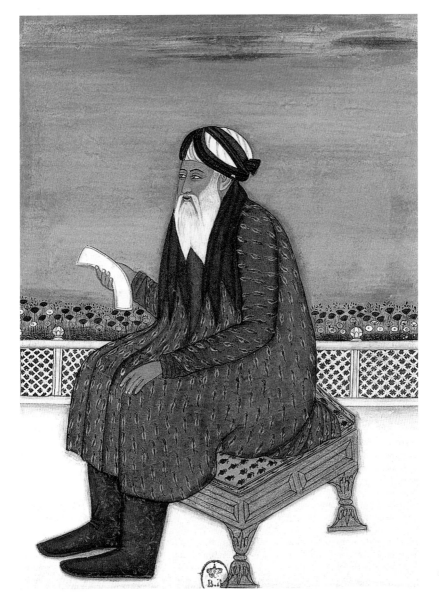

211

therefore, that even when the eighteenth-century mythological painting is placed on one side for separate treatment, the mass of material to be dealt with by the historian is enormous, and that it is not possible within reasonable limits to do more than select a small number of typical examples.

Many, perhaps most, of the extant Indo-Persian compositions are anonymous, but hundreds are signed, and it would not be difficult to compile a list of names of from one hundred to two hundred artists. Perhaps the most fruitful general observation

Durga mounted on a chimera

c. 1760, Murshidabad
Opaque watercolour, gold, and silver, 20 x 15.7 cm
Bibliothèque nationale de France, Paris

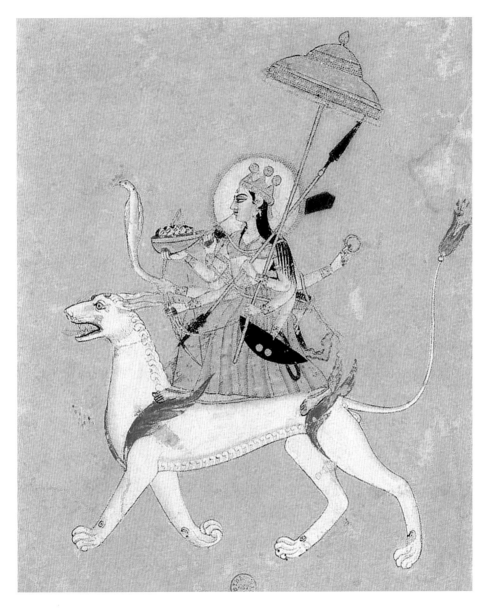

arising from such perusal of nominal lists is the predominance of Hindu names. In Abul Faz's catalogue of seventeen artists, only four are Muslim, while thirteen are Hindu.

Basawan is represented by Plate XXI of the *Razmnamah*, illustrating the story of the raja who married the daughter of the King of Frogs. The lady, divesting herself of her fine clothes, returned to the water and resumed her froggy form, whereupon the angry husband proceeded to kill all the frogs he could find, until the lady was restored to him.

Rabia in the company of a yogini

Painted in the Faqirullah Khan style
1760-1770, Faizabad
Opaque watercolour and gold, 18.5 x 11.3 cm
Bibliothèque nationale de France, Paris

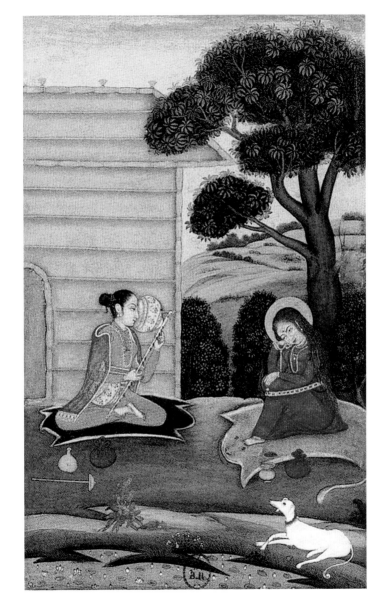

The prevailing colour is green in various shades. The birds, frogs, trees, and flowers are drawn and painted with the utmost delicacy, but the general effect is marred by the intrusion of blocks of manuscript. The perspective convention is the same as that of the ancient bas-reliefs. If the spectator imagines that all the persons and trees are on hinges and can be raised to their feet, they will then all fall into their proper relative positions. The artist saw with his mind's eye all the figures standing up,

Prince in his palace

c. 1760, Murshidabad
Opaque watercolour, gold, and silver, 22.6 x 12.5 cm
Bibliothèque nationale de France, Paris

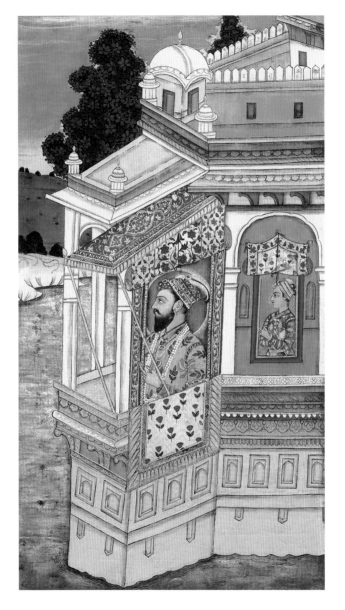

but in order to paint them, conceived them all to be laid down on one side. The subject seems to be regarded and viewed from above, all the parts being equally bathed in light, which is not represented as coming from any particular direction. Consequently, there are no shadows, and there is hardly any shading. Strong sunlight is indicated by a wash of gold behind the big tree. The drawing is by Basawan, the colouring by Bhawani.

Princess Padmavati

c. 1765, Faizabad
Opaque watercolour and gold
red border with garland of polychrome flowers
margin with bouquets of red flowers
22.7 x 16.5 cm; folio, 40.3 x 27.3 cm
Bibliothèque nationale de France, Paris

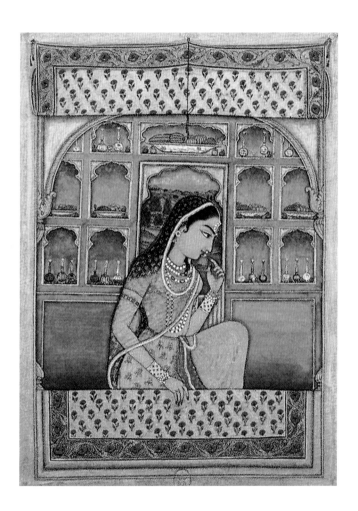

The Indo-Persian artists excelled in the delineation of animals, both quadrupeds and birds, and a delightful album might be composed of their pictures of animal life. The celebrated artist Ustad Mansur, who enjoyed the special favour of Jahangir, and was honoured by him with a title of nobility, began his career in Akbar's reign. The *Waqiat-i-Baburi* contains a series of eight exquisite little miniatures from his brush. Mansur, however, excelled as an animal and bird painter. His work is further represented in the India section of the Victoria and

Couple on a terrace at night

Follower of Govardhan II, c. 1765, Faizabad
Opaque watercolour and gold, 26.5 x 18.7 cm
Bibliothèque nationale de France, Paris

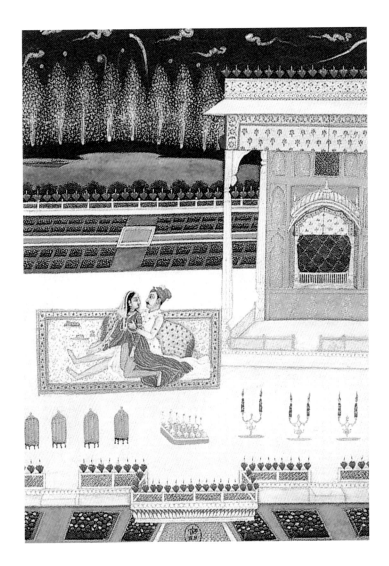

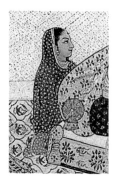

Albert Museum by Nos. 21, 22, and 23 of the Wantage Bequest, paintings of a peasant, a turkey-cock, and a blue-throated barbet. Havell has reproduced successfully a beautiful white crane by Mansur in the Calcutta Art Gallery. In Dara Shikoh's album only three pictures are dated (folios 25, 26, 21 b), the dates being AH 1014 (1605-1606 CE); AH 1018 (1609-1610 CE); and AH 1043 (1633-1634 CE). The first date being when the sceptre passed from the hands of Akbar to those of Jahangir;

Lady on a bed outdoors, accompanied by musicians

c. 1770, Faizabad
Opaque watercolour and gold, 27 x 17.1 cm
Bibliothèque nationale de France, Paris

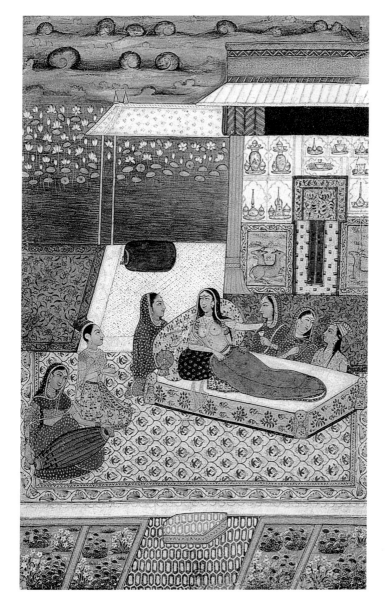

the third falls in the reign of Shah Jahan. Six of the paintings (folios 19b, 33b, 35b, and 45b) seem to include portraits of Jahangir (Prince Salim) in his youth and early manhood. The collection, as a whole, therefore, may be ascribed to the time of Jahangir and the earlier part of Shah Jahan's reign, or in other words, to the first forty years of the seventeenth century.

The only signed composition is that on Folio 21b (1633-1634) which bears the name of Muhammad Khan. The picture is characteristic

Safed 9 (moons 9)

Rectangular playing card or Mughal *genjifa*
Painted in the Mihr Chand style, c. 1770, Lucknow
Opaque watercolour, gold, and ivory lacquer
about 6.8 x 4.8 cm
Bibliothèque nationale de France, Paris

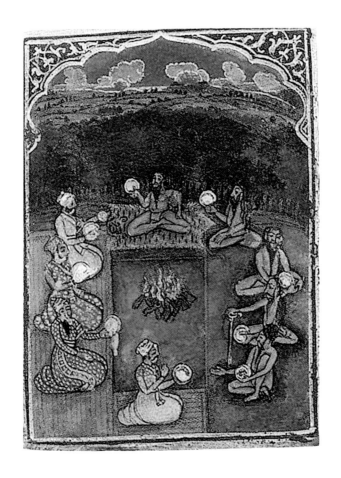

of Jahangir's bibulous court. It represents a young man clad in a bright yellow robe and large green turban, kneeling before a vase of flowers and a golden dish containing four earthenware jars, and engaged in pouring red wine from a jewelled goglet into a cup held in his left hand. No shading is used.

The birds in this album, exquisitely drawn and coloured, are worthy of Mansur and may possibly be from his brush. I admire particularly the picture on Folio 8 of a long-legged, brown bird standing by the side of a pool fringed with grass, flowers,

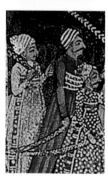

Shamsher 4 (sabers 4)

Rectangular playing card or Mughal *genjifa*
Painted in the Mihr Chand style, c. 1770, Lucknow
Opaque watercolour, gold, and ivory lacquer
about 6.8 x 4.8 cm
Bibliothèque nationale de France, Paris

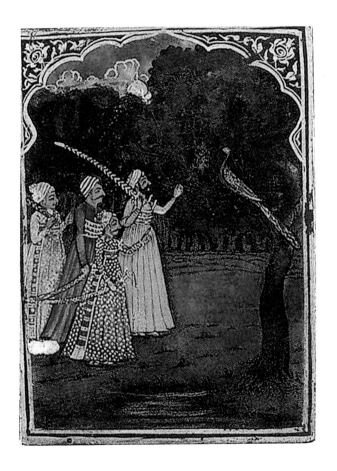

and bamboos in tolerably good perspective. The blue sky, unfortunately, is rather crude. Another remarkable bird study is that on Folio 10 representing admirably a wild duck standing by the side of a pool at the foot of a hillock. The sunlight on the face of the hillock is boldly indicated by a wash of gold, with surprisingly fine effect.

The works of the Indo-Persian draughtsmen and painters furnish a gallery of historical portraits, lifelike and perfectly authentic, which enable the historian to realize the personal appearance of all

Chang vazir (harp vizier)

Rectangular playing card or Mughal *genjifa*
Painted in the Mihr Chand style, c. 1770, Lucknow
Opaque watercolour, gold, and ivory lacquer
about 6.8 x 4.8 cm
Bibliothèque nationale de France, Paris

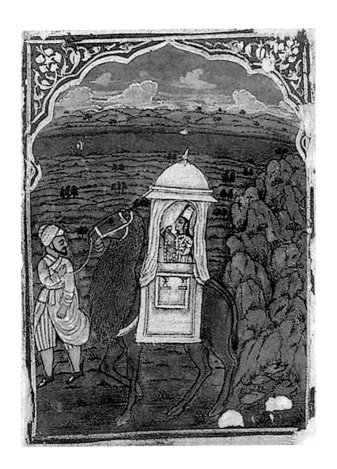

the Mughal emperors and of almost every public man of note in India for more than two centuries. It may be doubted if any other country in the world possesses a better series of portraits of the men who made history. Pictures of this class are so numerous, and so many of such excellence, that it is difficult to make a representative selection.

All critics, presumably, would admit that Indo-Persian art attained its highest achievements during the reign of the magnificent Shah Jahan (1627-1658 CE), when the land enjoyed peace,

Qimash 9 (cushions 9)

Rectangular playing card or Mughal *genjifa*
Painted in the Mihr Chand style, c. 1770, Lucknow
Opaque watercolour, gold, and ivory lacquer
about 6.8 x 4.8 cm
Bibliothèque nationale de France, Paris

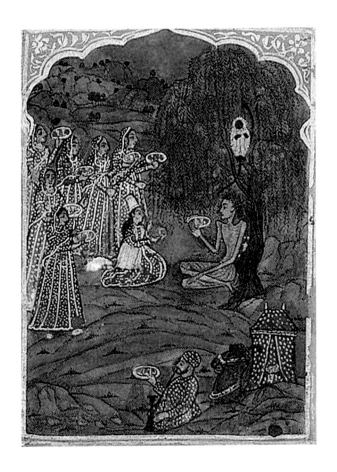

and a luxurious court offered liberal encouragement to all artists capable of ministering to its pleasure. The fierce scenes of bloodshed in which the earlier artists delighted were replaced by pageants of peaceful courtly splendour, the old aggressive colouring was toned down or dispensed with, and a general refinement of style and execution was cultivated. In the portraits of men and favourite animals a little shading executed by a few delicate strokes was dexterously introduced, sufficient to suggest solidity and roundness, and

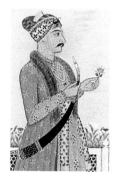

Indian prince smoking hookah

Sital Singh, c. 1775, Lucknow
Opaque watercolour and gold, 27.9 x 21.2 cm
Bibliothèque nationale de France, Paris

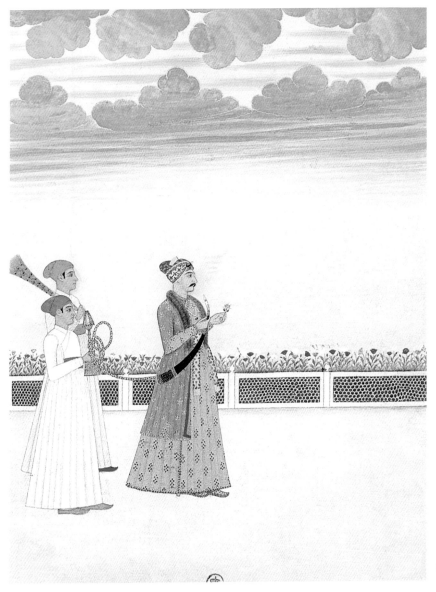

233

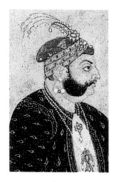

yet managed with such reserve that the Asiatic reliance on the power of line was not interfered with. The compositions of this period comprise a variety of subjects and are the work of many artists.

Perfectly drawn elephants are numerous. Indian artists, whether sculptors or painters, rarely failed to produce good representations of the huge quadruped, the nature of which they understood thoroughly. Volume LXVII in the Johnson Collection of Warren Hastings's banker Richard Johnson is specially devoted to elephants,

An Indian Prince

1775-1780
Opaque watercolour, 41.1 x 29.1 cm
Virginia Museum of Fine Arts, Richmond

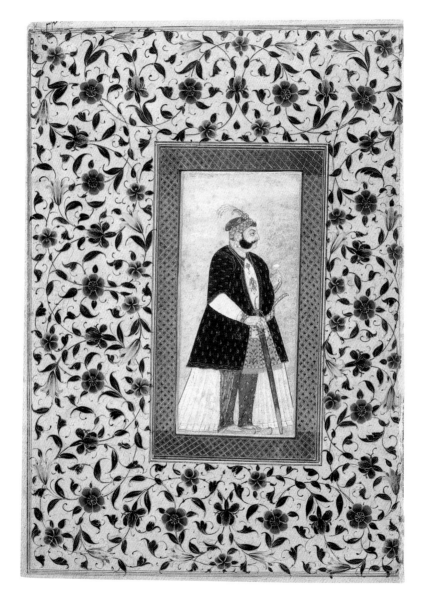

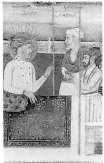

several of which are admirable. One of the best is that on Folio 7, by Nadir-uz-zaman (Abu al-Hasan). Another fine picture is that on Folio 15. The main subject is a magnificent elephant standing in a palace courtyard, with other elephants and a bullock as accessories. The drawing is grisaille in a brownish sepia tint, no other colour being used, except that the golden ornaments of the elephant are yellow.

The many charming pictures treating of miscellaneous subjects including illustrations of popular stories, offer a wide field for description and selection, far too large to be treated exhaustively.

Emperor Jahangir receives members of his court

c. 1790-1810, Patan, Gujarat
Opaque watercolour, 27.8 x 33.5
Virginia Museum of Fine Arts, Richmond

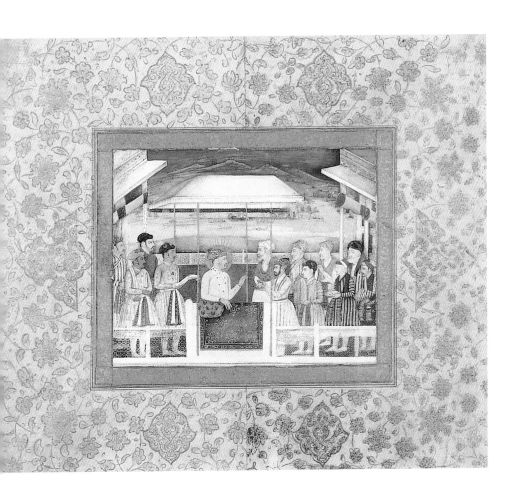

A favourite subject was the story of Baz Bahadur, king of Malwa, and his lady-love, Princess Rupmati, who are represented in several pictures as riding together by torchlight. Other romances frequently illustrated are the tales of Laila and Majnun, Khusrau and Shirin, and Kamrup and Kamta.

Havell has rightly drawn attention to the skill with which the Indian artists treated the contrast between the pitchy darkness of night and the flare of artificial light. Several pictures are extant

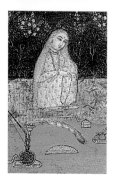

A woman visiting a yogini and
her companions at night

1800, Patan, Gujarat
Opaque watercolour, 24.6 x 16.7 cm
Virginia Museum of Fine Arts, Richmond

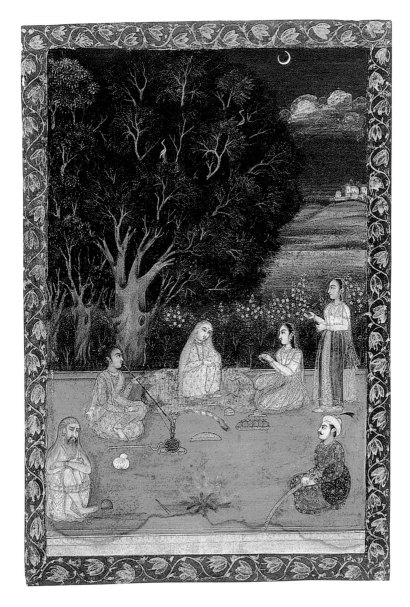

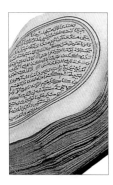

which exhibit this contrast in scenes of hunting by night, flaming torches being used to dazzle and hypnotize the deer. The same motive, which also attracted Rembrandt, inspires the pictures representing a lady standing on a balcony watching the effect of fireworks over the dark waters of the Jumna. Sometimes she is shown in the act of discharging a squib herself. Other compositions exhibiting people grouped round a campfire aim at like effects. Many artists took great delight in depicting holy men and ascetics

Miniature Qur'an, signed and dated,
with enamelled box, used as an amulet

Box: 19th century; Qur'an: 1555
Box: silver, green, and blue enamel
Miniature Qur'an: octagonal leaves, each 4.4 x 4.6 cm
379 folios each with 14 lines of *ghubari* script
within a 3.2 cm-wide circle, in black ink

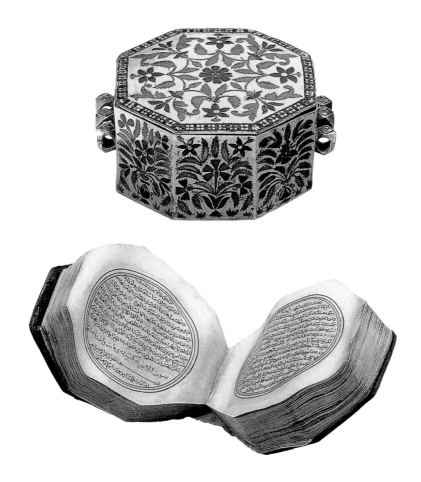

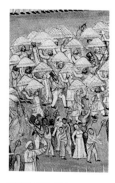

of all sorts, Muslim and Hindu, singly or in groups. Two of the most exquisite works dealing with this class of subject, and no doubt executed in the reign of Shah Jahan, are the companion pictures.

Most of the albums contain examples of gorgeous court scenes elaborated with infinite patience and minuteness of detail, harmoniously coloured, and often enriched with gold. It would be next to impossible to reproduce the most splendid of these pictures in colours with success, and I think it better not to make the attempt. The composition

A festival at the Nawab of Oudh's Palace

1830
Opaque watercolour and ink, 51 x 64.1 cm
Virginia Museum of Fine Arts, Richmond

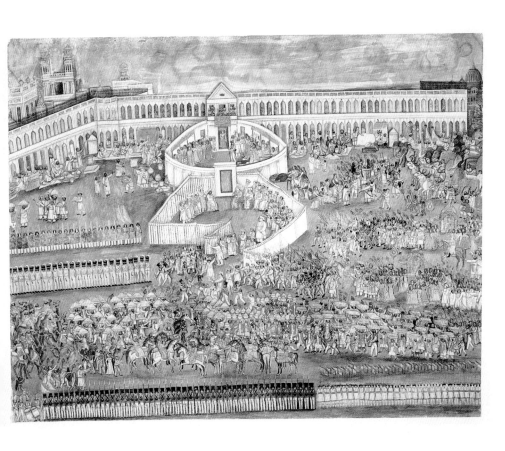

243

being the weak point in these works, photographs do them an injustice.

Passing on to the reigns of Aurangzeb (1658-1707) and his decadent sucessors during the eighteenth century, we find the artists still numerous and specimens of their work abundant. Although Aurangzeb was too zealous a puritan to care for art himself, the fashion set by his predecessors had not died out, and princes and nobles still kept court painters. Portraiture continued to be practised with great success,

Young prince hunting

c. 1830
Opaque watercolour and gold, 13.3 x 21.9 cm
Bibliothèque nationale de France, Paris

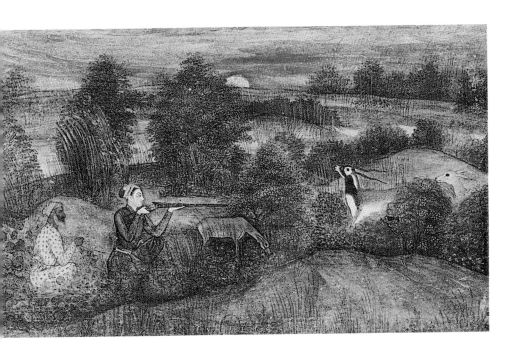

245

although the execution rarely attains the perfection of the first half of the seventeenth century. The art of this period and subsequent periods can only be justly treated of as the product of artists who gained a living at minor courts, Hindu or Muslim, and whose style and choice of subjects are modified by the local demand. Certain of these local styles, spoken of collectively as "Rajput", are distinct, but much of the later work remains true to the decadent Mughal tradition.

Musicians and attendants on a terrace

Left Side of a Double-Page Illustration to a *Masnavi*, 1830
Opaque watercolour and ink, 26.5 x 17.9 cm
Virginia Museum of Fine Arts, Richmond

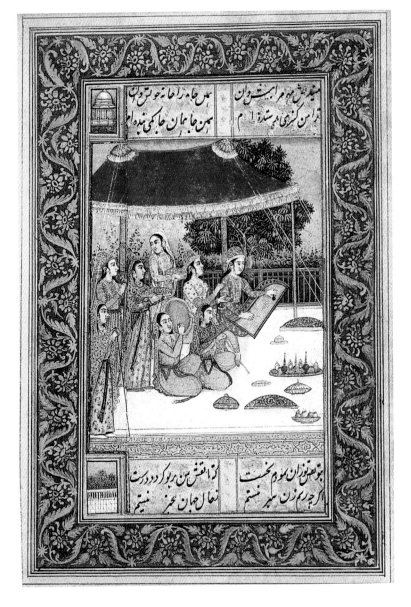

247

Index

A

Addicts consuming bhang 151

Akbar goes hunting 77

Arches in the Great Mosque Jama Masjid 13

The arrival of Nanda and his family in Vrindavan 27

Assembly of six Muslim doctors, **Manohar** (attributed to) 75

Aurangzeb at the siege of Satara, **after Mir Kalan Khan** 165

Azam Shah, **an artist of Golconde** (attributed to) 137

B

Bahadur Shah I (?) on an elephant 107

Bajazet brought before the Emperor Timur 169

Baz Bahadur and Rupmati, **Faizullah Khan** 175

Bhairavi regini 173

C

Calligraphic album page (Nasta'liq script), **Abd al-Rahim** 67

Caravan of elephants 185

Cavalier Kathi 201

Chang vazir (*harp vazier*) 229

Cheik Abu Said Abil-Khair 45

Cockfight 21

Composite elephant preceded by a div (*demon*) 121

Couple of imperial pigeons 93

Couple on a terrace at night, **follower of Govardhan II** 221

Crossing the Ganges by Akbar, **Ikhas and Madhou** 49

D

Dara Shikoh (?) 53

Davalpa mounted on a man 23

Defying Mihrdoukht 4

Diwan-i-Khas (*Hall of Private Audience*) 11

Durbar (*court*) *of Shah Jahan in Lahore where he receives Aurangzeb* (detail) 131

Durga mounted on a chimera 213

E

Elephant, **Faqirullah Khan** 157

Emperor Humayun 43

Emperor Jahangir receives members of his court 237

Emperor Shah Jahan holding an iris 127

Episode from the tale of The False Ascetic 25

Episode from the tale of The Lynx and the Lion, **Niccolò Manucci** 17

European lady 125

European Scene 57

Events during the Reign of the Abbasid Caliph al Mutasim 33

F/ G

A festival at the Nawab of Oudh's Palace 243

Fight of two elephants, **Farrukh Chela** (attributed to) 73

Flowers of two colours, blue and red 103

Guru Arjan Dev on a horse 195

H

Horse, **Faqirullah Khan** 159

Hulagu Khan destroys the Fort at Alamut,

 Basawan (illustrator) and **Nand Gwaliori** (colourist) 35

Humayun and his brothers in a landscape,

 Fathullah (?) (attributed to) 115

Humayun Mausoleum 9

I

Ibrahim Adham, Sultan of Balkh, served by five houris 189

Imperial Firman of the Emperor Aurangzeb 129

Indian dignitary, perhaps Raja Suraj Singh 81

An Indian Prince 235

Indian prince smoking hookah, **Sital Singh** 233

Indian princess surrounded by her attendants and musicians,

 Bishan Das (or Bishandas) (attributed to) 111

Interior of the Sheesh Mahal (Hall of Mirrors) 31

I'timad-ud-Daulah Mausoleum 87

K

Kakubha ragini 69

Khosrow sees Shirin at the bath,

 Mir Kalan Khan (attributed to) 153

L

Ladies on a terrace by the water's edge 163

Lady on a bed outdoors, accompanied by musicians 223

Lord in a winter coat with his wife 149

Lord Pathan on horseback, armed with a spear 6

M

Madava Swooning Before Kamakandala (front), **Shiv Das** 139

Madava Swooning Before Kamakandala (back), **Shiv Das** 141

Megha Raga 71

Miniature Qur'an 241

A Mughal Prince 99

Muhammad awakened by the archangel Gabriel 203

Muhammad Khan Bangash 147

Mullah Du Piyaza 143

Murder in a landscape 19

Musicians and attendants on a terrace 247

Muslim women in prayer 109

Muzaffar Khan quells a revolt at Hajipur 37

N

Niccolò Manucci 135

Nightlife scene in a royal zenana, **Chitarman**, also known as **Kalyan Das** 179

Nuns and musicians, **follower of Faqirullah Khan** 183

O

Ornate façade of the Akbar Mausoleum (detail) 51

Ornate façade of the I'timad-ud-Daulah Mausoleum 89

P

Persian falconer 85

Persian noble and musician 83

Persian on a hunt 79

Portrait of a Mughal Lady 113

Portrait of Kishn Das Tunwar, **Kanha** 29

A Prince and his retinue hunting waterfowl 177

Prince in his palace 217

Prince Khusrau hunting, **Basawan or Manohar (?)** (attributed to) 65

Prince Muazzam Shah Alam hunting 133

Prince on a terrace surrounded by six women 187

Prince with a snack 61

Princess at her toilette 161

Princess led by her servants to the nuptial bed,
 follower of Govardham II 193

Princess Padmavati 219

The Prophet Idris (*Enoch*) 59

Purple and white flower 97

Q

Qimash *9* (*cushions 9*) 231

Qur'an 47

R

Rabia in the company of a yogini 215

Ram 101

Ram Singh of Amber 123

Rama and Lakshmana Meet 55

S

Safed 9 (moons 9) 225

Scholar in a garden, surrounded by servants and musicians 63

Shah Jahan hunting 205

Shah Madar surrounded by disciples, perhaps **Dal Chand** 207

Shah Nimat ullah Wali 211

Shamsher 4 (sabers 4) 227

Sheikh Saadi and Khwaja Hafiz, **follower of Dip Chand** 167

Shuja Quli Khan on a terrace in the company of a lady 181

Swooning Madhava, **follower of Faqirullah Khan** 191

T

Taj Mahal 117

Three red tulips 91

Two butterflies on grass, **Fathulla (?)** 95

Two Portuguese during conversation 105

Two travellers in landscape, **Mirza Nadir Das** 119

V

Visit of a Sufi to a school 39

The voyage of Zulaikha (detail), **Bahadur Singh (?)** 199

W

A woman visiting a yogini and her companions at night 239

Women in the country under a mango tree 145

Y

Yogi at the edge of a river, **Bahadur Singh (?)** (attributed to) 197

Young girl with parrot 15

Young lord in his zenana 155

Young prince hunting 245

Yusuf arrives at Zulaikha 171

Yusuf going to meet Zulaikha, **Bahadur Singh (?)** (attributed to) 209

Z

Zaal pleads with the Simurgh to save his son Rustam, **Miskin** (attributed to) 41